# WORLD FILM LOCATIONS
## MELBOURNE

Edited by Neil Mitchell

First Published in the UK in 2012 by Intellect Books, The Mill, Parnall Road, Fishponds, Bristol, BS16 3JG, UK

First Published in the USA in 2012 by Intellect Books, The University of Chicago Press, 1427 E. 60th Street, Chicago, IL 60637, USA

Cover photo: *Malcolm* (1986) © Cascade Films / Film Victoria

Copy Editor: Emma Rhys

A Catalogue record for this book is available from the British Library

**World Film Locations Series**
ISSN: 2045-9009
eISSN: 2045-9017

**World Film Locations Melbourne**
ISBN: 978-1-84150-640-1
eISBN: 978-1-84150-678-4

Printed and bound by Bell & Bain Limited, Glasgow

# WORLD FILM LOCATIONS MELBOURNE

EDITOR
Neil Mitchell

SERIES EDITOR & DESIGN
Gabriel Solomons

CONTRIBUTORS
Myke Bartlett
Gem Blackwood
Dean Brandum
Julian Buckeridge
Jez Conolly
Adrian Danks
Glenn Dunks
Lisa French
Kristina Gottschall
Scott Jordan Harris
Alexandra Heller-Nicholas
Emma Jane McNicol
Neil Mitchell
Whitney Monaghan
Jack Sargeant
Fiona Trigg
Deb Verhoeven
Yasmin Vought
Sarah Ward

LOCATION PHOTOGRAPHY
Steve Davidson and Amber Moriarty

LOCATION MAPS
Joel Keightley

PUBLISHED BY
Intellect
The Mill, Parnall Road,
Fishponds, Bristol, BS16 3JG, UK
T: +44 (0) 117 9589910
F: +44 (0) 117 9589911
E: *info@intellectbooks.com*

Bookends: Melbourne Harbour (Amber Moriarty)
This page: *Blessed* (2009)
Overleaf: *Noise* (2007)

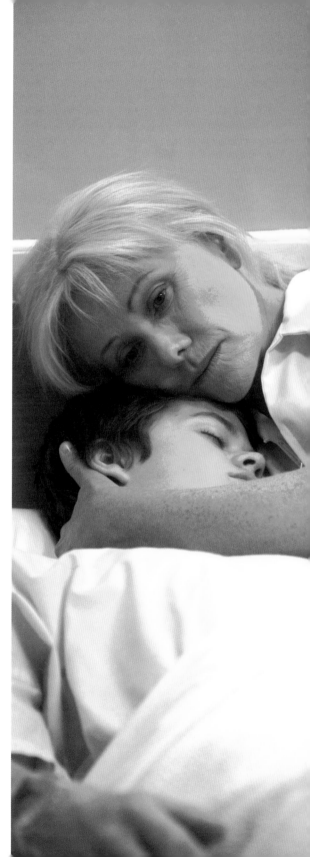

# CONTENTS

## ACKNOWLEDGEMENTS

I would like to thank Gabriel Solomons and all the staff at Intellect Books for their sterling work behind the scenes on all of the *World Film Locations* editions. Special thanks must go to Adrian Danks and Dean Brandum for their invaluable input, all of the writers for their excellent contributions, and Amber Moriarty and Steve Davidson for their location photographs. Alan Hodge, John Berra, Scott Jordan Harris, Jez Conolly and Dave Phoenix deserve a nod of appreciation, as do my parents, family, and friends for their unwavering support.

NEIL MITCHELL

# INTRODUCTION

## *World Film Locations* Melbourne

THE WORLD FILM LOCATIONS SERIES aims to highlight the importance of location to narrative in film, which we attempt to showcase through the interplay between image and text. This visually led series foregrounds physical environments, specifically locations in the great cities of our world, and the role they play in establishing, contradicting or strengthening the emotional spaces of the characters that inhabit them. Many of these locations, especially those off the tourist trail, are introduced to viewers for the first time on the big screen, instantly creating an impression of 'the city' in question formed through the use of genre, narrative drive, and existing reputations employed by the film-makers.

This edition of the series, like the others, makes no claims to be comprehensive or set in stone, but seeks to open up the avenues of debate as to how film plays into and further enhances how we think about life in an urban environment. Through 46 short individual scene analyses from 46 individual films, complimented by half a dozen themed essays, our contributors, drawn from the worlds of academia, journalism and the blogosphere, offer up their views on the myriad representations of Melbourne on the big screen.

Whilst Melbourne may not spring to mind as one of cinemas great locations, in the way that London, New York, Paris and Rome do, it has in fact been ever present on the big screen since the advent of the art form, and film-making and cinematic representations of the city are to this day an essential part of the make up of the 'cultural capital of Australia'. As well as being the birthplace of the Australian film industry, Melbourne gave the country its television industry, Australian Rules Football, the New Vogue and the Melbourne Shuffle dance styles, and the impressionist art movement known as The Heidelberg School. In August 2011 the state capital of Victoria, which shares such a passionate rivalry in all matters with Sydney, was voted 'the world's most livable city' by The Economist Intelligence Unit (EIU), and its burgeoning population of more than four million, well over 30 per cent of whom were born overseas, are amongst the most cosmopolitan on the planet. Granted city status in 1847 by Queen Victoria, Melbourne grew wealthy during the Victorian Gold Rush, experienced periods of boom and bust, hosted the 1956 Olympics and the 2006 Commonwealth Games, and was the second city, after Edinburgh, to be named a UNESCO City of Literature.

Whether the cinematic visions are of the Yarra (the 'river that runs upside down', due to its constantly muddy appearance), the Hoddle Grid in the Central Business District, the beaches of Port Philip, or the suburbs of St Kilda, Fitzroy, Collingwood or Brighton, and whether they spring out of the comedy, drama, crime or coming-of-age genres, one thing can be said for certain when watching the films set, or partially set in the city – they all play a significant part in how we conjure up the idea of 'Marvellous Melbourne' in our collective imaginations. �

**Neil Mitchell, Editor**

# MELBOURNE

## *City of the Imagination*

Text by
ADRIAN
DANKS

**MELBOURNE HAS BEEN** a relatively ubiquitous presence in the cinema since the very first films shot by a Lumière cameraman in Australia in late 1896. These initial Australian films feature iconic (Derby Day, part of the Melbourne Cup Carnival) and relatively indistinct images of the city that set up a paradigm for Melbourne's representation that continues to this day. This combination of iconic identifiability – determined by such elements as Melbourne's seeming obsession with sport and the 'marvellous' Victorian-era architecture that defines the city's popular identity – and indistinctiveness, is reflective of the city's geography, history, cultural identity, and insistent competitive relationship to the more obviously spectacular and picturesque Sydney. Melbourne, arguably defined as a 'second city' in contradistinction to its northern counterpart, is often considered more cultured, more literary, more livable (the 'world's most' according to various highly publicized polls), more structured (it served as Australia's administrative capital and parliament in the early years after Federation), less brash, and as a place that you must spend time in to truly experience. Melbourne-set films, complete with the difficulties they encounter in introducing the city and finding easy markers of identification, are defined by a dispersed and piecemeal psycho-geography of the city. For example, it takes someone intimately versed in the byways and microscopic detail of Melbourne to know the precise locations used in such important films as *Animal Kingdom* (2010), *Noise* (2007) and *Romper Stomper* (1992). This group of films suggests the importance of down-at-heel, gritty realism, and the crime genre to the labyrinthine, low-key imagination of Melbourne-set cinema. Although fleeting images of the skyline and muddy Yarra River feature in numerous films, it is the horizontality of such inner-city suburbs as St Kilda, Richmond, Carlton and Footscray, as well as fractured glimpses of the urban grid, that characterize 'Melbourne cinema'. As a result, Melbourne's cinema is often iconically and representationally heterogeneous; temporally and spatially indistinct.

At most points in Australian film history its cinema has largely been centred and/or focused elsewhere (even if the money was often found in Melbourne). There is a reason this book offers only a few examples from the vast period leading up to the late 1960s and the emergence of what is called the 'Carlton School' and the feature film 'revival' spurred by such varied films as *The Adventures of Barry McKenzie* (1972), *Alvin Purple* (1973) and *Picnic at Hanging Rock* (1975). The cinema of these earlier periods is generally preoccupied by either the immensity of the non-urban landscape or (much less often) the inner urban terrain of Sydney. There are few dominant or defining images of Melbourne in these early films, and one needs to look towards documentary to find a denser thicket of representation. It is also quite revealing that although what is now commonly claimed as the first feature film made anywhere in the world, Charles Tait's *The Story of the Kelly Gang* (1906), was shot in Melbourne but is not actually set there. This stands in contrast to such a remarkable artefact as Charles Cozens Spencer's Marvellous *Melbourne: Queen City of the South* (1910), a short documentary celebrating the majestic inner-city thoroughfares and civic icons of Victorian-era Melbourne, the legacy of its massive boom in the Gold Rush led-era of the 1860s,

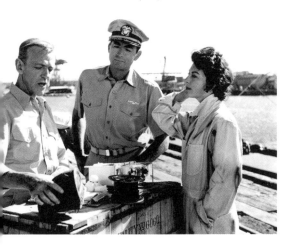

more desirable, exotic and cosmopolitan cities. In keeping with this, Melbourne is often used as a cinematic stand-in for any number of other places: the light, sensibility and actuality of Europe in various Paul Cox films; for Victorian London in the TV-movie *The Ripper* (1997); for the Boston area in *Knowing* (2009); and to evoke the architectural and municipal memory of an older, and now dead Europe and America in *On the Beach*. This is an approach to the malleability and imagination of Melbourne that is also reflected in the touristic, liberal practices of the Melbourne Film Office in promoting the city as a de facto film set, and the construction and operations of the Docklands Studios where such fantastical movies as *Where the Wild Things Are* (2009) and *Ghost Rider* (2007) were produced.

Probably the most widely circulated statement about Melbourne is that apocryphally credited to Ava Gardner as she left the city after the production of *On the Beach*: 'I'm here to make a film about the end of the world... and this seems to be exactly the right place for it.' Although Gardner's negative comment reflects lingering doubts about the geography and worldliness of Melbourne, and certainly skewers the muted sensibility of the desiccated *On the Beach* itself, it does little to account for the dynamic and often varied uses to which the city has been put in the movies of the last 45 years. The Melbourne cinema of this era is, as I have remarked, still characterized by the city's transformability, but is also memorable for the stream of visiting Bollywood productions that highlight the more photogenic and breezy elements of the city, the endless number of crime films and television programmes emphasizing the dispersed and centrifugal qualities of the sprawling suburban metropolis, the combinatory action choreography of the Jackie Chan vehicle *Mr. Nice Guy* (1997), and the series of Carlton-based films of the1960s and 1970s that redefine ideas of the city and its cultural and cinematic markers (more Italian neo-realism and Godard than Hollywood or British cinema). In these and other films across more than a century, Melbourne emerges as truly a city to be (re)imagined. ✢

1870s and 1880s. Although made around the time of the completion of one of the city's most identifiable buildings, the majestic Flinders Street Station originally destined for Mumbai, and full of images taken from the front of the city's ubiquitous trams, it is really a nostalgic marker of an earlier, more buoyant moment.

The opening moments of Stanley Kramer's American produced but Melbourne shot *On the Beach* (1959), probably the defining 'Melbourne' film, are emblematic of this representational indistinctness and slipperiness. As an American submarine enters the heads of Port Phillip Bay there are no identifying landmarks, nothing that marks what we see (except for the local spectator, perhaps) as identifiably Melbourne. There is no shot of the skyline, no title-card, nor a montage of explicit views, attractions or identifying features. This is part-and-parcel of a general difficulty of conceiving of Melbourne as a 'landmark' city or as a city of landmarks. In his 1997 book *Twins*, Chris Gregory addresses some of these issues by conceptualizing Melbourne as a city of doubles, twins and copies; where each recognizable building apes the facades, features and memories of other

**At most points in Australian film history its cinema has largely been centred and/or focused elsewhere (even if the money was often found in Melbourne).**

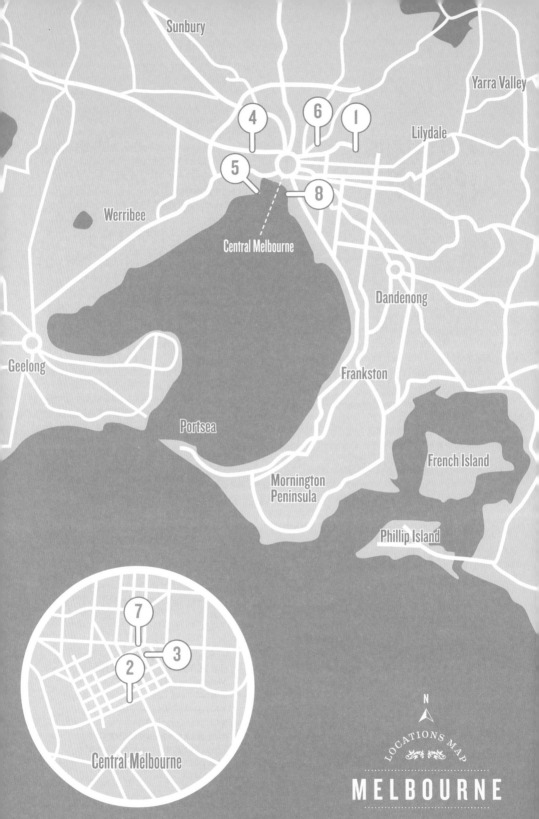

Sunbury

Yarra Valley

4  6  1

Lilydale

5

8

Werribee

Central Melbourne

Dandenong

Geelong

Frankston

Portsea

French Island

Mornington
Peninsula

Phillip Island

7

2  3

Central Melbourne

N

LOCATIONS MAP

MELBOURNE

maps are only to be taken as approximates

# MELBOURNE LOCATIONS

## SCENES 1-8

# THE STORY OF THE KELLY GANG (1906)

LOCATION

*The former Chartersville Estate, now part of Heidelberg, VIC 3084*

**THE STORY OF THE KELLY GANG** was a bold undertaking. At the turn of the twentieth century, films were generally at most ten minutes in length. The Story originally ran for an hour, and is thought to be the world's first narrative feature-length film. The film is classically Aussie in how it 'bats for the underdog'. The Kelly gang are good blokes with a bit of cheek, protecting decent citizens from corrupt police, 'larrikins' who take the time to remove their hats for ladies. The film advertised itself as being shot on location at the 'real' Glenrowan Inn, where the 'real' Kelly gang had been overpowered and seized. In actual fact, most of the film was shot on a property owned by the Tait family, known as the Chartersville estate, now part of the suburb of Heidelberg. A replica of the inside of the Glenrowan Inn was built for the film's iconic showdown. In this scene, the police set the pub alight to smoke out the Kelly brothers hiding within. As the pub cinders the film is dyed a violent pink. Inside, two of the gang accept their fate. Outside, Ned, dressed in homemade armour, is shot and seized. Over the past century, Melbourne's expansion has consumed the leafy Chartersville estate and pushed rural life in general to the outskirts of the city. The film is a relic from some of our enterprising ancestors, the energy of whom made Melbourne the dynamic metropolis it is today.
**➻ Emma Jane McNicol**

(Photos © Amber Moriarty)

*Directed by Charles Tait*
Scene description: *The showdown at the Glenrowan Inn*
Timecode for scene: *0:10:16 – 0:15:50*

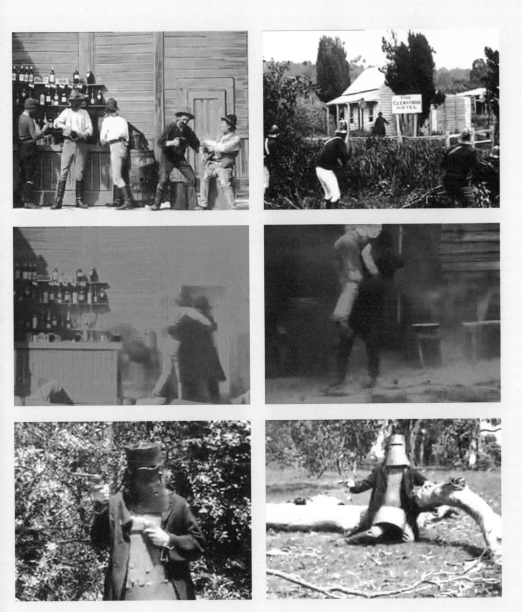

# MARVELLOUS MELBOURNE: QUEEN CITY OF THE SOUTH (1910)

*Flinders Street Station, corner of Flinders and Swanston Street, VIC 3000*

**FLINDERS STREET STATION** is undoubtedly one of Melbourne's most iconic buildings. Posed on one of the city's busiest intersections it has a wonderful baroque grandeur that seems to rise above the bustle beneath. The front steps, topped with clocks announcing the next departing trains, remain a popular meeting place for tourists, estranged friends and suburban teens. Yet the story goes that Flinders Street Station is not very Melbourne at all. Rumours suggest the plans for the building – built between 1905 and 1910 – were actually intended for Mumbai. A mix-up when the plans were posted from London resulted in a piece of East Indian architecture becoming the principal landmark in Australia's cultural capital. Even if Melbourne's true train station did wind up thousands of miles away, it is understandable that *Marvellous Melbourne* would feature the Flinders Street landmark. Filmed the year the building was created, the short documentary is keen to show off the city's wealth, with footage lingering over rooftops and admiring such structures as the Royal Exhibition Building – built three decades earlier – which here seems to rival the grandest European palace. Part of a journey that takes us along St Kilda Road and up onto the Swanston Street shopping strip, our glimpse of Flinders Street Station is, however, decidedly fleeting. Indeed a jump in the film ensures that we leap from an approach to a departure, but here the building's domed roof seems to guard the city gates. Gliding up this enviously-empty, tree-lined avenue, we recognize exactly where Melbourne proper begins. **Myke Bartlett**

(Photo © Lakeyboy: wikimedia commons)

*Directed by Charles Cozen Spencer*
*Scene description: Along St Kilda Road*
*Timecode for scene: 0:01:55 – 0:02:31*

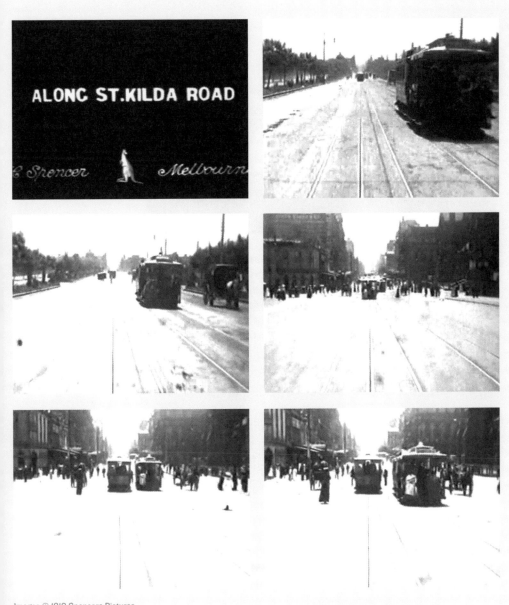

# HIS ROYAL HIGHNESS (1932)

LOCATION *Her Majesty's Theatre, 219 Exhibition Street, VIC 3000*

**POPULAR VAUDEVILLE PERFORMER** George Wallace brings his knockabout, working-class persona to the screen as Tommy Dodds, a stage hand transported to the mythical kingdom of Betonia, courtesy of a wallop to the back of the head. Fittingly, *His Royal Highness* (released in the United Kingdom as *His Loyal Highness*) was filmed on the stage of Her Majesty's Theatre, which was used by Frank Thring Snr's company Efftee Productions as a film studio while the auditorium was closed for several years due to fire damage. The palace sets lend an airy grandeur to the action, which, while never losing the sense of a stage act transplanted somewhat clumsily to film, captures Wallace's slapstick style. Mistaken as the heir to the throne, Tommy is presented to the court, where he is momentarily floored by the formality and pomp of proceedings, executing his trademark pratfall onto his left ear, and sending his crown flying. Quickly adapting to his new role, Tommy joins in with the courtiers and sing a chorus of 'I am the king of Betonia'. Tommy organizes a 'poncy' uniform and knighthood for his mate Jim (John Dobbie), and sacks the Prime Minister. Upsetting the plans of an evil courtier, Tommy discovers the identity of the true heir only to be bundled – via another knock to the head – all the way back to the wings in Melbourne. Opened in 1886 as the Alexandria, Her Majesty's was heritage listed in 1986 and remains in use as a theatrical venue. **•Fiona Trigg**

(Photo © Steve Davidson)

*Directed by F. W. Thring*
*Scene description: Tommy in Betonia's throne room*
*Timecode for scene: 0:31:05 – 0:39:46*

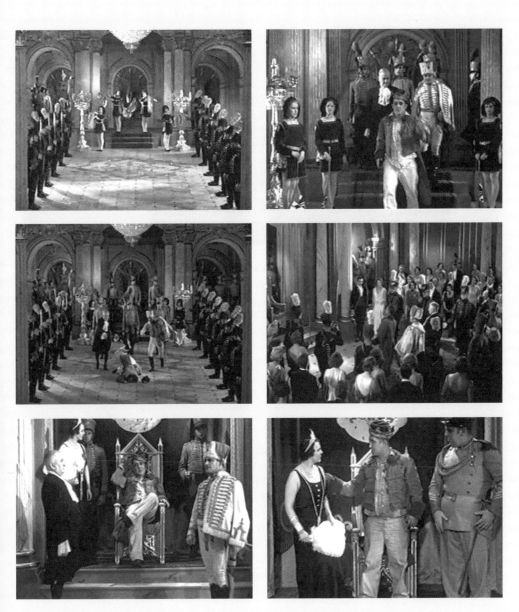

15

# THOROUGHBRED (1936)

LOCATION *Flemington Racecourse, 400 Epsom Road, Flemington, VIC 3031*

**THE AUSTRALIAN FEATURE FILM** of the 1930s and 1940s is lacking in representative images of Melbourne. With the curtailment of activity at Frank Thring's Melbourne-based Efftee Studios in the mid-1930s, Ken G. Hall fully emerged as the central figure of the Australian feature film industry, introducing various technologies, synergies and economies of scale. *Thoroughbred* was the first Australian film to use the relatively new technique of rear-projection: a key technology of cinematic modernity that allowed streamlined production and an unprecedented control of the filmed environment. The film itself tells the fairly hackneyed tale of an emaciated and neglected thoroughbred, Stormalong, who battles against adversity to win the Melbourne Cup before dying at the finish line, after being shot by a sniper. The extended Cup Day sequence is a delirious combination of stock footage, garish and sometimes ill-matched rear-projections, location shooting, studio composition, rapid montage, and the 'actuality' of Melbourne and the rarefied realm of Hall's Sydney (Bondi Junction) studio. Resonating loosely with the legend of Phar Lap's fate (poisoned) in America, Hall's excitingly staged sequence offers a piecemeal representation of one of Melbourne's most iconic events – the film is both there and also somewhere else. This achieves its most head-spinning articulation in the swiftly edited moments when the sniper first battles against the protagonist and then aims his rifle towards the patently 'projected' images of the race. *Thoroughbred* is remarkable for its transformation of an actual event into a sub-Hitchcockian spectacle of action and intrigue. ◄•*Adrian Danks*

(Photo © Amber Moriarty)

*Directed by Ken G. Hall*
*Scene description: 'Stormalong has won his last race, sir.'*
*Timecode for scene: 1:13:05 – 1:20:30*

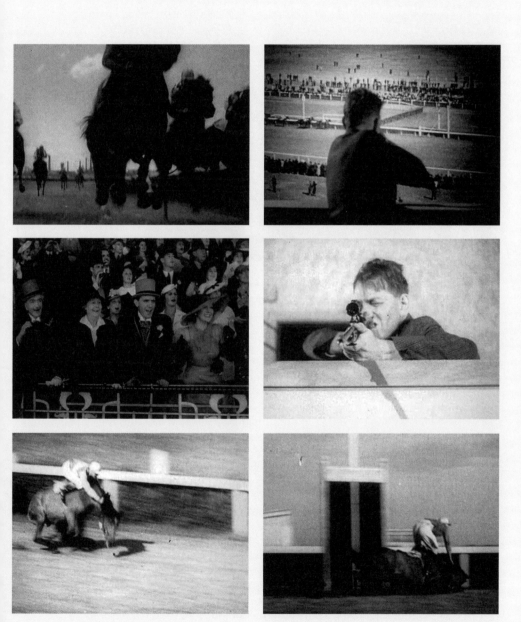

# ON THE BEACH (1959)

LOCATION *Williamstown Naval Dockyard, Williamstown, VIC 3016*

**NEVIL SHUTE'S PRE-APOCALYPTIC NOVEL** placed Melbourne as the last habitable place on Earth and director Stanley Kramer assembled a Hollywood A-list cast, including Gregory Peck, Fred Astaire and Anthony Perkins, to be present at the world's end. It was an uncomfortable shoot for the stars, with temperatures topping 110 ˚F. Ava Gardner's first appearance sees her striding coolly along the wharf at Williamstown Naval Dockyard with *HMAS Melbourne* berthed behind her, in order to board the Royal Navy submarine *HMS Andrew*. The dockyard dates back to 1858 when the first slipway was built, followed fifteen years later by the completion of the Albert Graving Dock. Shipbuilding at Williamstown began in 1913 and its output saw action in both world wars. For Gardner's scene on the pier, it is said that so many sailors hung over the side of the *Melbourne* that the ship developed a five degree list to starboard. The actress blanked their cheers and applause as she made her way between vessels, remaining focused even after trapping the heel of one of her stilettos between two planks. Slipping her foot out of the shoe she continued on her way as the cheers from the disregarded ratings turned to boos. Adding insult to injury Gardner, in an interview for the *Sydney Morning Herald*, was quoted as suggesting that Melbourne in the summer was an ideal place to make a film about the end of the world, although much later journalist Neil Jillett admitted concocting the line because Gardner had refused to be interviewed. **↝ Jez Conolly**

(Photo © Steve Davidson)

*Directed by Stanley Kramer*
*Scene description: End of the pier show at the end of the world*
*Timecode for scene: 0:35:23 – 0:36:21*

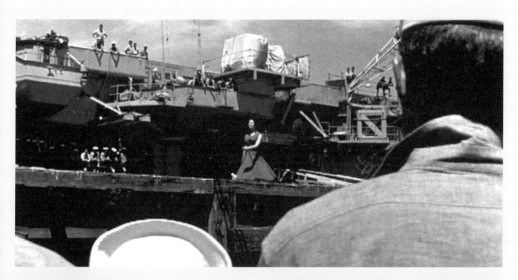

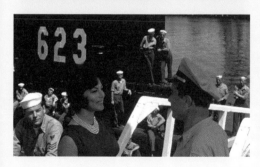

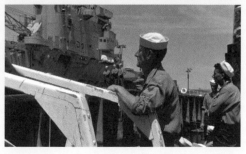

# NINETY NINE PERCENT (1963)

LOCATION *Gold Street State School, Clifton Hill (now Clifton Hill Primary School), 185 Gold Street, Clifton Hill, VIC 3068*

**GIORGIO MANGIAMELE** is one of the most important if least appreciated post-war Australian film-makers. His intermittent but persistent work in the 1950s and 1960s represents one of few true expressions of migrant life in the Australian cinema of this era. Mangiamele's films are remarkable for the particular view they present of the rapidly changing inner city suburbs of Carlton and Clifton Hill, and the voice they give to the alienated experience of Italian migrants 'assimilating' into the Anglo-Saxon 'norms' of Australian society. These films are also striking for their visual composition, clearly reflecting such European influences as neo-realism (at one point in the film the characters seem to wander through the kind of bombed-out streetscape that is more Rossellini's Rome than Melbourne). *Ninety Nine Percent* is the fourth and last of Mangiamele's films of migrant experience; it is also the only (bittersweet) comedy. Like the other films, it is concerned with the immediate, daily experience of its characters and the microscopic detail of the physical environments they inhabit. As in many of the ambulatory films of neo-realism, *Ninety Nine Percent*'s characters wander the streets in search of experience and identity. But Mangiamele's film is also aspirational. In a scene staged at the Gold Street State School in Clifton Hill, an adjacent suburb to Carlton, Joseph Pino learns of his embarrassed son's burgeoning academic abilities. Set within the grounds of this Victorian edifice, Mangiamele's film gently restates its contrast between ethnic and mainstream Australia, while merging together the audio-visual traditions of Italy and Australia. ↦*Adrian Danks*

(Photo © Amber Moriarty)

*Directed by Giorgio Mangiamele*
*Scene description: 'Learn to read'*
*Timecode for scene: 0:12:40 – 0:18:24*

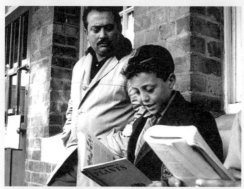

Images © 1963 NFSA

# NED KELLY (1970)

*Old Melbourne Gaol, 377 Russell Street, Melbourne, VIC 3000*

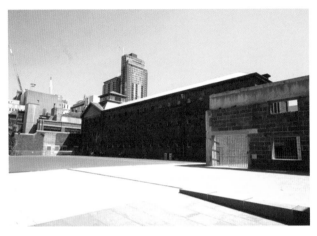
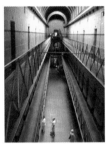

**IN A FILM SEEMINGLY** more interested in riffing on a legend than troubling itself with the truth, the opening scene, where our titular hero meets his end, at least makes a gesture towards reality. As stylized as this snappily-edited sequence is, with the snap of the photographer's camera echoing the crash of the hangman's trapdoor, this is as close as we get to the real Ned Kelly. Filmed in the Old Melbourne Gaol and standing Mick Jagger on the same scaffold where Kelly was hung, it certainly chills the bones. Walking the Gaol today, that same chill is impossible to ignore. Like many stone buildings with such history, the place always feels far colder than it should, regardless of the weather. On paper, it made sense for director Tony Richardson to cast Mick Jagger. Rock was a decade old and the Rolling Stones were poster boys for the glamorous, dissolute life it promoted. Connecting these early rock stars to colonial outlaws was an easy leap for the director to make. Unfortunately, just as Richardson is more interested in the legend of Kelly than the truth, he seems to have cast Mick Jagger the legend, instead of Mick Jagger the actor. It is only in this first scene that his decision really makes sense. As the camera flashes and Jagger poses in Kelly's prison cell, we are allowed a peculiar sense of double-vision. Here Jagger and Kelly co-exist. Even allowing for Jagger's strangled accent, there is a real horror in seeing Britain's leading rockstar led to his death on the gallows. ⟶ **Myke Bartlett**

(Photos © Steve Davidson)

*Directed by Tony Richardson*
*Scene description: Ned's hanging*
*Timecode for scene: 0:00:20 – 0:03:18*

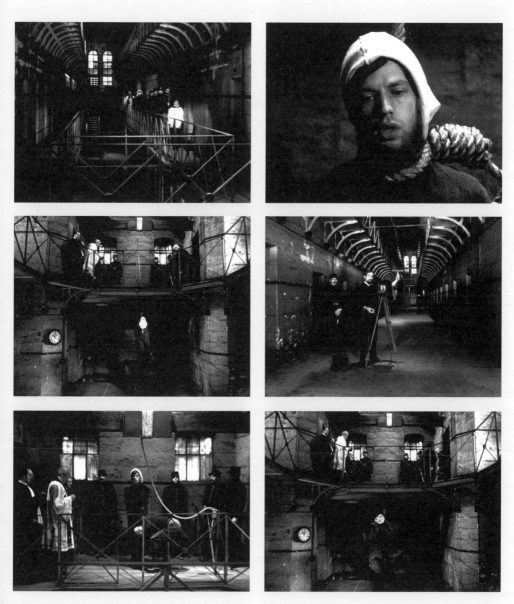

# THE NAKED BUNYIP (1970)

*Luna Park, 18 Lower Esplanade, St Kilda, VIC 3182*

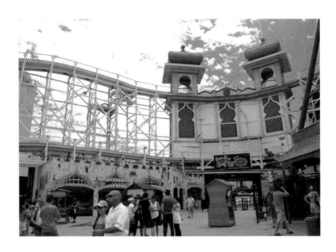

**THE NAKED BUNYIP** is a somewhat forgotten but influential work of the 1970s Australian feature film revival. Following the exploits of a naive, shy young man (Graeme Blundell) selected by an advertising agency to conduct a survey of sexual habits and behaviours, it is a curious hybrid of fiction and documentary, farce and social commentary, exploitation and education, Sydney and Melbourne. John B. Murray's independent production profiles a range of fictional (Edna Everage) and real-life commentators and personalities (Aggy Read, Jackie Weaver, Beatrice Faust, Russell Morris et al.), and traverses the 'sexual' geography and history of Melbourne (including a stop at the site of the famous nineteenth century brothel, Madame Brussels, in Lonsdale Street) and Sydney. Its epic scope and piecemeal construction allow for numerous digressions. One such moment occurs during an interview between Graeme and a photographer, leading swiftly to a brief photo shoot at St Kilda's Luna Park. This scene juxtaposes the matter-of-fact discussion between the two men, the troublingly mute model and the depopulated amusement park, while downplaying the salacious and erotic elements of the shoot and the park's various attractions: Graeme ogles an old-fashioned peep show while also viewing his image in the crazy mirrors. This sequence is now fascinating for its refreshing view (we never seen the iconic moon face of the entrance) of a now irreversibly altered Luna Park, stripped of many of its earlier attractions. There is a quaintness and surprising frankness to *The Naked Bunyip* that draws it close to the iconic Melbourne sexual comedies of the coming years.
•◦ **Adrian Danks**

(Photo © Steve Davidson)

Directed by *John B. Murray*
*Scene description: 'Is there no end to my depravity?'*
*Timecode for scene: 0:36:20 – 0:39:01*

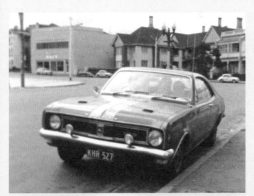

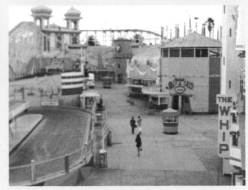

Images © 1970 Southern Cross Films Pty. Ltd.

# MELBOURNE STUDIOS

Text by
DEB
VERHOEVEN

**FILM STUDIOS ARE** a materialization of the optimistic bravura so often associated with the production of movies themselves. Chutzpah made concrete. Brio in bricks. Their fortunes capture the aspirations of the entrepreneurs who built them and the political investments of the governments who backed them. Their failures signal the social shifts and technological challenges that have dogged the Australian film industry for more than a century. Melbourne's earliest foray into studio-based film production is one such story of early success and unanticipated change. The Salvation Army's Limelight Department was one of the world's first vertically integrated film studios – undertaking production, distribution and exhibition of a steady stream of movies, some 400 films from 1897 to 1909. To support their burgeoning enterprise they constructed what may well be the world's first purpose-built studio, a small attic space next to an existing photographic studio in their Melbourne headquarters in Bourke Street in 1898. But this space alone could not contain the Salvos' expanding taste for film production. By 1900, the film segments of their ambitious religious epic Soldiers of the Cross (an ingenious mix of slides, films, oratory and music) were also shot at the Murrumbeena Girls Home and the Richmond

Baths. Within the year the Limelight Department had created another studio, in Murrumbeena (not far from Chadstone Shopping Centre). In 1908, they built another again, in the suburb of Caulfield. But by 1910, and with no forewarning, it was all over. The appointment of a new Army Commissioner possessed with an active disdain for the frivolity of popular entertainments announced the end of the Limelight Department's pioneering productions.

The films made in their various studios set the tone for later studio-based production in Melbourne. Religiously inspired stories such as *The Scottish Covenanters* (Joseph Perry, 1909) (set in Oliver Cromwell's England) were easily distinguished from the Department's auspicious location-based commissions (royal visits, grand openings and so on). Melbourne's various studios have almost always been called on to create the impression of times and places *other* than contemporary Melbourne. Within their walls, distant worlds are conjured and captured. These global aspirations, at least at the level of film production, are now extended to Melbourne itself which offers up its streets as an easy back-lot of urban ersatz. The official *FilmMelbourneNow* website boasts: 'You've already seen our city incognito in many international feature films, doubling as Boston, Texas, New York, 1950's Maine, London and Chicago. We love leading a double life.'

The story of Australian cinema is typically told as an adversarial battle in which a swashbuckling hero-film-maker fights a pitched and pyrrhic battle against an array of overwhelming opponents. In this telling, each finished film is a hard fought victory, an emblem of national persistence, a possibly never-to-be-repeated event. The story of small-industry studios based outside the major movie metropolises runs counter to this sketch of embattled national entrepreneurs. Here instead are slates of production, local

companies imbricated in global distribution networks and international finance.

Frank Thring established Efftee Film Productions in 1930 after selling his substantial shareholding in Hoyts to the Fox Film Corporation. For a studio Thring secured the lease for His Majesty's Theatre which had not yet been restored after a disastrous fire in 1929. Whilst Thring was comparatively prolific (producing many shorts and features in the early 1930s), in the end only four films were made at this studio; *A Correspondent's Course* (1931), *Diggers* (1931), *The Haunted Barn* (1931) and *His Royal Highness* (1932). Controversy thwarted Thring at every turn. The Victorian Censors classified *Haunted Barn* and *Correspondent's Course* as unsuitable for children (6–16-year-olds) causing Thring to threaten to leave Melbourne for Sydney or London. Instead, he sold his studio's entire output and in 1933 he gambled it all, establishing his own premises on the Esplanade in St Kilda (now the site of the Novotel Hotel) claiming his Wattle Path studios to be the largest in Australia. The studio immediately went into production on *A Ticket in Tatts* (1934) featuring the very bankable comedian George Wallace. But only seven months after its triumphal opening Thring announced the impending closure of Wattle

**Melbourne's various studios have almost always been called on to create the impression of times and places other than contemporary Melbourne.**

Path. This was in part a preemptive threat in Thring's campaign for a quota system for Australian films. Thring was unsuccessful in convincing the Victorian government to pass the necessary legislation and upped his entire operation to Sydney when the NSW government did (1936). So as soon as the London-located *Clara Gibbings* (1934) and *Streets of London* (never publicly released in Australia) were completed, production at Wattle Path was suspended. Thring sailed off to Hollywood in search of talent only to return to Australia to a premature death.

In all Efftee produced nine features, more than 80 shorts and several stage productions, and just prior to Thring's death, had extended its financial interest into radio operations (Efftee was the first licensee of Melbourne radio station 3XY). Thring's dramatic departure to Sydney put a dampener on all but documentary and newsreel production in Melbourne for many years. The significant presence of television studios including the Crawford Studios (spanning the 1960s to 1990s) and the establishment of the Melbourne Film Studios by film-making duo David Parker and Nadia Tass in 1991 (before a devastating fire in 1999) represent brave forays into studio production in this period.

With the Docklands Studios (formerly Melbourne Central City Studios) the story has turned full cycle, resuming the creative enterprise of imagining other worlds and times. Primarily catering to foreign producers, the Docklands Studios were established in 2004 on the basis of an earlier government report into Melbourne's slipping competitiveness for offshore movie dollars. It quickly developed a reputation for drama behind the scenes surviving a scathing government report, long periods of dormancy, public antipathy, industry criticism and wild currency fluctuations. Films such as: *Charlotte's Web* (2006), *Ghost Rider* (2007), *Where the Wild Things Are* (2006) and *Knowing* (2009) have availed themselves of its facilities. The studio is complemented by the Point Cook Film Studio which specializes in water-based filming. Featuring one of only three horizon tanks in the world it has been a destination for US television movies such as *Noah's Ark* (1999) and *Moby Dick* (1998). ✦

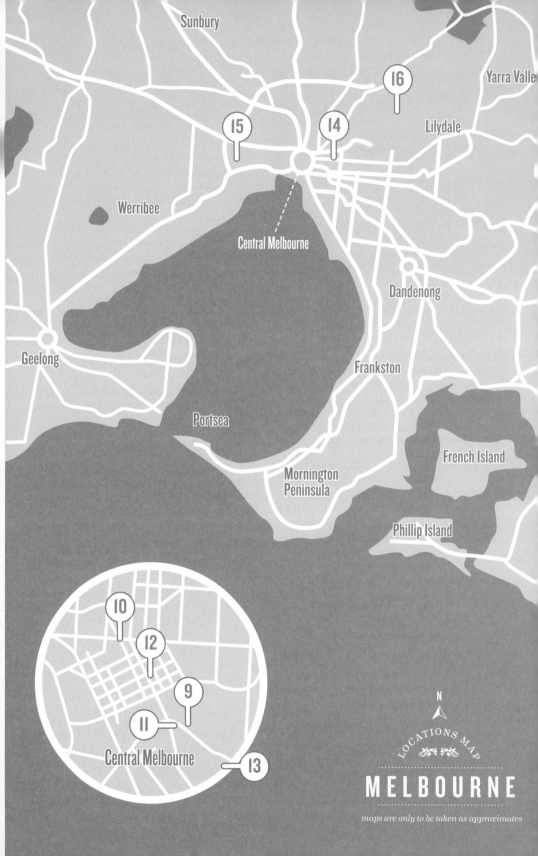

# MELBOURNE LOCATIONS

## SCENES 9-16

# ALVIN PURPLE (1973)

LOCATION *Yarra River near the Swan Street Bridge, Capital City Trail, Melbourne*

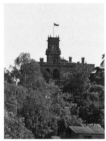

**ALVIN PURPLE**, the quintessential popular Australian film of the 1970s, follows the ribald adventures of its seemingly ordinary title character (Graeme Blundell) who finds himself the centre of non-stop female attention. Consciously conceived as 'Carry On Australia', this proudly lowbrow sexploitation film was the highest grossing Australian film of the decade, and its carnival of boobs and bums suggest director Tim Burstall had little interest in political correctness. Burstall's film is a series of loosely linked sexploitation vignettes surrounding Alvin's exploits from schoolboy to waterbed salesman to gigolo. Its appropriately named climax finds Alvin chased to a skydiving centre by the angry husbands of the many unfaithful wives whose sexual exploits were previously revealed. Hiding on a plane, he is forced to jump and lands in the iconic Yarra River with Melbourne's early 1970s cityscape draped behind him. Renowned locally as 'the river that runs upside down' because of its muddy water, a drenched and dirty Alvin struggles onto the shores of Alexandra Gardens only to find himself hunted yet again by a group of sexually excited women. Alvin is chased across the Yarra, past St Paul's Cathedral down busy daytime Swanston Street, and arrives at the corner of Elizabeth and Collins Street, where he falls into the stern but safe arms of a local policeman. With its sexual absurdity peaking at one of Melbourne's most familiar landmarks, Alvin is finally permitted to leave the public realm of sexual spectacle to a private one of true love. **⟿ Alexandra Heller-Nicholas**

(Photos © Steve Davidson)

*Directed by Tim Burstall*
**Scene description:** *Skydiving into the Yarra River*
*Timecode for scene: 1:21:05 – 1:26:46*

# PURE SHIT (AKA PURE S) (1975)

*Victoria Market Pharmacy, 523 Elizabeth Street, VIC 3000*

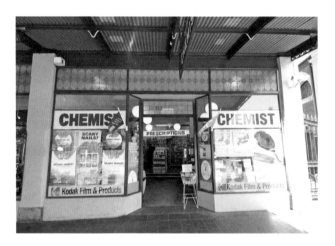

**SET AT A CRACKING PACE,** *Pure Shit* is an episodic romp through a few days in the lives of a group of heroin addicts living in inner-city Melbourne. Unconcerned with character development or any particular narrative arc, the film tumbles from one incident to the next as the four lead characters chase their next hit and stay one step ahead of the law. - Neither romanticizing nor demonizing its characters, the film presents police busts, chemist break-ins, fatal overdoses, paranoid coke dealers, art-crowd parties, graphic injecting scenes, and a bizarre rehabilitation clinic as everyday elements in the world of the drug user. Laced with a streak of anarchic humour – novelist Helen Garner has a memorable cameo as a speed freak – the lack of moral condemnation outraged cultural gatekeepers at the time of the film's release. *Pure Shit* was shot on the fly around various inner city suburbs, in particular Carlton, which at the time offered cheap accommodation for students and the community of writers and performers based at The Pram Factory theatre (now a shopping centre), which was used as one of the locations. The film has few establishing wide shots; it cuts to the chase in anonymous backstreets, bedrooms, and nocturnal car interiors. The chemist shop at Queen Victoria Market still operates today, although the Carlton lane way used for the approach no longer exists. The lane way used for the escape remains part of the Market complex on Elizabeth Street, although the cast iron gates have been removed. **→Fiona Trigg**

(Photo © Amber Moriarty)

*Directed by Bert Deling*
**Scene description: The heist on the chemists' shop**
**Timecode for scene: 0:30:32 – 0:33:58**

# OZ: A ROCK 'N' ROLL ROAD MOVIE (1976)

LOCATION *Sidney Myer Music Bowl, 21 Linlithgow Avenue, VIC 3004*

**'C'MON, LET'S GO** and see the farking wizard then!' In Chris Löfvén's joyful and little-seen adult adaptation of Frank Baum's *Wizard of Oz* tale, a seedy-looking Melbourne of the mid-1970s stands in for the fictional Emerald City. The heroine Dorothy (Joy Dunstan) is a music groupie, the 'scarecrow' (Bruce Spence) is a surfie, and the 'tin man' (Michael Carman), is an auto-mechanic who in a quite literal verbal pun consumes 'tinnies' of beer. Dorothy and her eccentric posse travel across rural Victoria to reach the wizard (Graham Matters), in this retelling an extravagant glam-rock musician attired in Bowie-esque splendour. In this scene, Dorothy has snuck into the concert venue and sees the wizard on stage for the first time. The film's real live music scenes were actually filmed at popular outdoor concert venue the Sidney Myer Music Bowl, which was built for the city in 1959. Director Löfvén was able to translate the pent-up feeling of crowd frenzy onto the screen by filming between the performances of two now legendary Australian bands, The Little River Band and AC/DC. The show captures a sense of the city as a rock Mecca, an alluring but also dangerous place. Dorothy's sense of joy and hysteria is facilitated by the use of some psychedelic post-production special effects that warp and distort the musicians like a trompe *l'oeil* caused by the hot outback sun. The ultimate moral of the story though? As Dorothy utters in the film's denouement: 'fame and fortune fuck you up.' **➥ Gemma Blackwood**

(Photo © Steve Davidson)

*Directed by Chris Löfvén*
Scene description: *Dorothy arrives in Melbourne to see the 'Wizard' perform*
Timecode for scene: *1:09:00 – 1:15:26*

# ABBA: THE MUSICAL (1977)

LOCATION

*Melbourne Town Hall, 90-120 Swanston Street, VIC 3000*

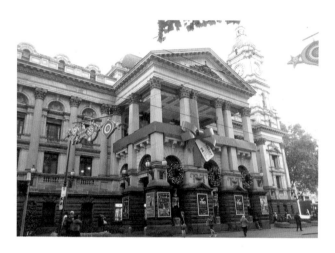

**IN ABBA: THE MUSICAL,** the titular Swedish superstars may not quite give us the classic The Beatles managed with *A Hard Day's Night* (Richard Lester, 1964), but they do present an indelible record of the intensity of the 'ABBAmania' that followed them on their March 1977 tour of Australia. The film's most famous scene is perhaps the most famous episode of ABBA's career, and depicts them simply standing on a balcony waving to a crowd. But what a balcony – and what a crowd. The balcony belongs to Melbourne's Town Hall. The crowd belongs entirely to ABBA. The town hall was built in the Second Empire style by Melburnian architect Joseph Reed over two decades, between 1867 and 1887, and was expanded early in the twentieth century. It is a magnificent structure and emblematic of the city it serves. Never, though, has it had the worldwide exposure brought by this single scene in this silly but unforgettable film. Standing on its ornate balcony, the band-mates, visibly shocked by the scenes below, are worshipped like newly married royals or a particularly popular Pope. It is a short scene: there is no dialogue besides the impatient chants of 'We want ABBA!', and no music at all, but it conveys more about the power of pop music than would a dozen documentaries on the subject. *ABBA: The Musical* has the tagline 'It Seemed the Ovation Would Never End'; watching the group wave from the balcony of Melbourne Town Hall, we struggle to believe it ever did. **➻Scott Jordan Harris**

(Photo © Steve Davidson)

*Directed by Lasse Hallström*
*Scene description: 'We Want ABBA!'*
*Timecode for scene: 1:18:33 – 1:20:00*

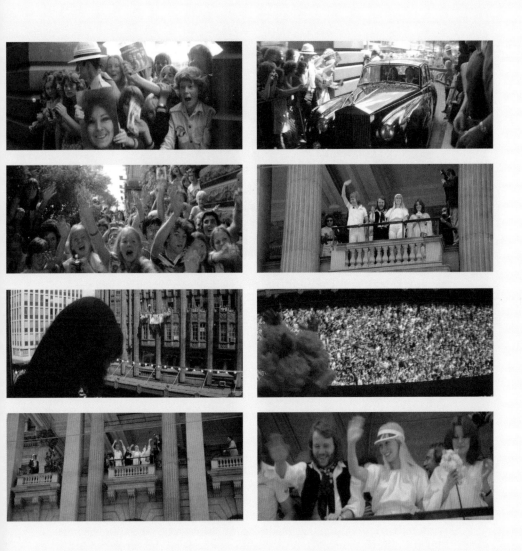

# PATRICK (1978)

*Simonds Hall, 120 Toorak Road West, South Yarra, VIC 3141*

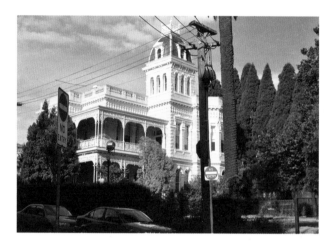

**ARRIVING AT ROGET'S CLINIC** on the number 8 tram – the same route that still runs along the quiet opulence of Toorak Road West today – the first view nurse Kathy Jacquard (Susan Penhaligon) is granted of her soon-to-be workplace occurs in the sparkling Melbourne sunshine. Nestled across from picturesque Fawkner Park, the building that is now (somewhat ironically) a Catholic education conference centre, is one of the few remaining Victorian mansions in the area. Looming conspicuously amongst the art deco styled apartment blocks that surround it, it is easy to understand why it reminded director Richard Franklin of the iconic Bates mansion from Hitchcock's *Psycho* (1960). As an elderly patient points Kathy towards the site of her interview, a broken neon 'Emergency Entrance' sign instead reads 'Emergency... trance', foreshadowing Kathy's impending encounter with Robert Thompson's eponymous psychic coma patient. Between this ominous signage and the silence of her guide, there is a sense even before entering that Roget's Clinic is a building haunted by the living. This becomes more apparent with the introduction of Matron Cassidy (Julia Blake), whose aggressive interview verges upon rudeness as she explains the sexual perversions of previous staff to Kathy, weighing the responsibility of this legacy upon her. With less interest in Kathy's moral standards than her professional experience, Dr Roget (Robert Helpmann) approves Kathy's appointment, and Matron Cassidy sends the new staff member to Room 15: Patrick's room. It is here where Kathy's bizarre nightmare begins in earnest, as Patrick's comatose infatuation takes a dangerous supernatural form. ➻ *Alexandra Heller-Nicholas*

(Photo © Amber Moriarty)

*Directed by Richard Franklin*
**Scene description:** *Arriving at Roget's Clinic*
**Timecode for scene:** *0:04:08 – 0:08:53*

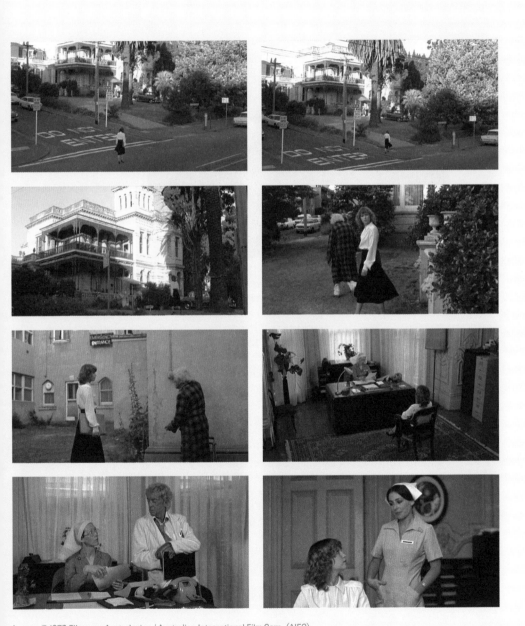

# THE GETTING OF WISDOM (1978)

LOCATION *Tiddeman House, Methodist Ladies' College, 207 Barkers Road, Kew*

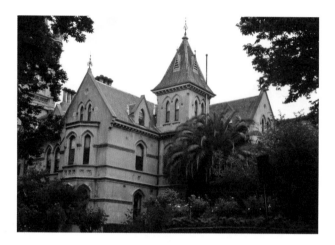

**ROMANTIC AND INQUISITIVE,** country gal Laura Tweedle Rambothan (Susannah Fowle) has been collected from Spencer Street Station by two teachers from her elite girls' school. She has come a long way, travelling first by stage coach and then steam-train from her small, dusty country town in rural Victoria where she lives with her widowed post-mistress mother and sister. A horse-drawn buggy takes the new boarder through the city streets to Melbourne Ladies' College. Craning herself out the window to see, her teachers mock her colourful homemade dress and bonnet, Laura knows she does not look quite right. When they arrive at their destination, Laura hops out of the buggy and is overshadowed by the imposing sandstone school. Although comparable to *Picnic at Hanging Rock* (Peter Weir, 1975), The Getting of Wisdom (from the novel by H. H. Richardson), is a far cry from the former's depiction of pretty girls so ethereal they disappear into the heavens. Rather, Beresford's film is grounded in the cruelty of the world of rich, bitchy girls, and the tough competitiveness of class and gender hierarchies. The architecturally similar Tiddeman House, dating back to 1882 and now the present-day boarding house of the Methodist Ladies' College was used as a stand in for the Presbyterian Ladies' College, which had been demolished in 1958. The original Presbyterian school building was constructed in 1875, at an estimated £12,000, on Albert Street opposite the Fitzroy Gardens. The school moved to its current location in Burwood the same year the original was demolished. •➔***Kristina Gottschall***

(Photo © Amber Moriarty)

*Directed by Bruce Beresford*
*Scene description: Arriving at Melbourne (Presbyterian) Ladies' College*
*Timecode for scene: 0:04:46 – 0:06:06*

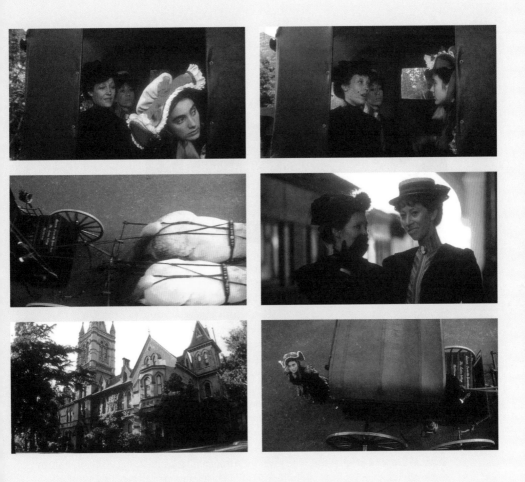

# MAD MAX (1979)

*Cherry Lane, Laverton North, Altona, VIC 3018*

**GEORGE MILLER'S OZPLOITATION** classic *Mad Max* is a high octane, dystopian vision of social breakdown, murder and revenge, in which the lines between law and order and anarchy are mercilessly crossed. As well as making a star out of its lead Mel Gibson and showing the world that it is not just Hollywood that can shoot memorable, kinetic action sequences, Mad Max also deftly used locations that represented the narrative themes explored during Main Force Patrol (MFP) officer Max Rockatansky's descent into barbaric savagery, whether they be rundown urban spaces, rolling freeways or rural retreats. During the film's eleven minute opening chase scene, in which escaped gang member Nightrider (Vince Gil) tries to outrun the MFP in a stolen V8 Interceptor pursuit vehicle, is a set piece action sequence filmed on Cherry Lane, in the largely industrial suburb of Laverton North. Situated on the outskirts of the city, roughly 18 km to the west of the CBD, Cherry Lane becomes the place where untamed criminality and social order violently clash. Symbols of civilization – a mother and toddler, telephone box, touring caravan, police cars – are alternately terrorized and destroyed as the drug fuelled Nightrider and his female companion career their way through the otherwise everyday environment. From the outset Miller positions the city as a place of relative safety amidst a hostile surrounding environment, and the chaotic destruction witnessed in the Cherry Lane sequence is an early warning sign of the increasing danger those trying to maintain the rule of law come to face. **⇢Neil Mitchell**

(Photo © Amber Moriarty)

*Directed by George Miller*
*Scene description: 'Christ, they're headed for population'*
*Timecode for scene: 0:06:10 – 0:08:50*

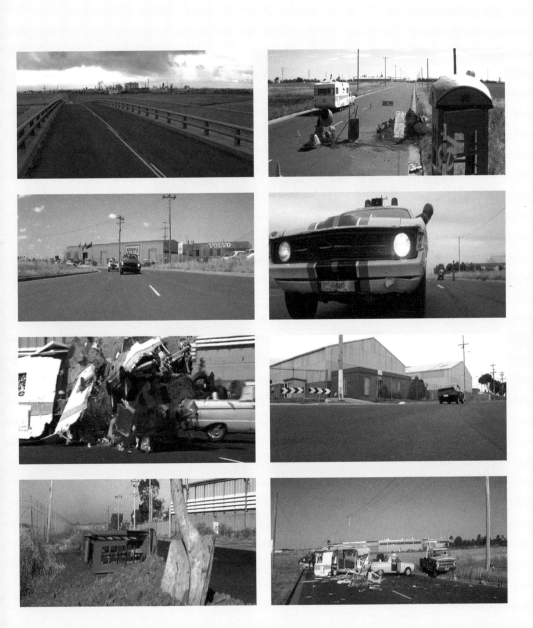

# THIRST (1979)

*Montsalvat, artists' colony, 7 Hillcrest Avenue, Eltham, VIC 3095*

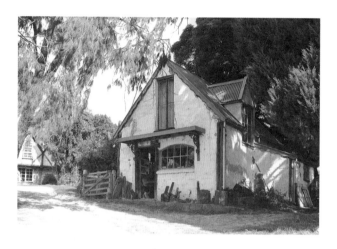

**LESS A SUPERNATURAL CULT** than a class-conscious corporate body, the Hyma Brotherhood seek to convince Kate Davis (Chantal Contouri) – a direct descendent of Countess Elizabeth Bathory – to join them. Filmed at the historic Montsalvat artists' colony in the outer Melbourne suburbs, Mrs Barker (Shirley Cameron) and another high-ranking member of the Brotherhood introduce Kate to their lush headquarters while explaining their rejection of the label 'vampire': instead, they see themselves as a 'superior race' for whom the drinking of blood is 'the ultimate aristocratic act'. Vampire traditions are further thwarted in this postmodern horror film as the zombie-like 'donors' and the Hyma members themselves wander in the bright sunshine amongst white picket fences, playing tennis, painting, and indulging in other recreational activities. The primary threat facing Kate is not destruction but assimilation as she struggles to resist a class structure that sees 'donors' reduced to little more than free-range human beings for the rich. Montsalvat's pleasant and sumptuous surroundings may serve most immediately to provide a shocking contrast with the abject horrors of vampirism that underpins the Hyma Brotherhood's business-as-usual rhetoric. But Montsalvat's status as an artists' colony – built in 1935 by architect Justus Jorgensen – to some degree assists in inter-textually rendering it distinct from the banal, everyday realities of the world that lie just beyond its boundaries. For Melburnians, Montsalvat has historically represented an oasis of creativity and imagination, and the Hyma Brotherhood's 'human farm' speaks of a privileged separation between the fantastic and the real. ◆*Alexandra Heller-Nicholas*

(Photo © Amber Moriarty)

*Directed by Rod Hardy*
**Scene description: The Human Farm**
**Timecode for scene: 0:13:12 – 0:15:07**

# HARDBOILED MELBOURNE

Text by
JACK
SARGEANT

**MAPPED, PLANNED** and constructed over the past 175 years, Melbourne has already become, like the former penal colony's other cities, resolutely suburban. The Victorian state capital's comparatively small downtown lies on the banks of the Yarra, surrounded by vast suburbs, land subdivided to best facilitate the realization of the Australian Dream; the desire to own a house with a garden on a quarter acre of land. The rectangle of city blocks that form downtown appear small on the map of the city, a grid tilted askew amongst a vast array of neighbourhoods. Fed by major roads and serviced by a network of trams and trains, the feeling beyond the inner city is one of sprawl, as suburbs spread seemingly endlessly outwards. This is the world made famous through television's *Neighbours* (Reg Watson, 1985– ) and *Kath & Kim* (Gina Riley and Jane Turner, 2002– ).

But in these over exposed, sunburned streets there is also a palpable darkness at play. Crime is deeply embedded in the collective cultural memory of the country, and in Melbourne there is a long history of criminality, transgression, revenge

and justice, stretching from legendary bushrangers, such as Ned Kelly, who met their demise at the hands of the executioner at Old Melbourne Gaol, through to the present day crimes that define any modern urban environment. Perhaps it is the proximity to this bloodied history that has made stark realism and a search for authenticity so central to Melbourne's most powerfully realized crime films.

Various inner city suburbs form the backdrop to *Pure Shit* (aka *Pure S*; Bert Delling, 1975) including Collingwood, Carlton and Fitzroy, as well as the city's freeways. The film follows a quartet of Melbourne druggies as they spend a night crammed in an old FX Holden driving from shitty apartments to various dealers via chemists and urban wastelands, all in their endless search for heroin. A cultural map of 1970s Melbourne, the film's protagonists criss-cross the inner city suburbs in their nocturnal quest. *Pure Shit* becomes a narcotic psychogeography of the city circa 1974, presenting a shifting landscape, inhospitable and full of risk for the junkies fixated on their task. The repetition of driving serves to add a velocity to the narrative, which is matched by the speed of events, while simultaneously echoing the mindlessness of their endless quest for drugs.

*Pure Shit*'s tale of low-level petty crime, remorseless drug addiction, and social fragmentation drew from the experiences of drug users interviewed during the scriptwriting process, and the movie has a gritty feeling of palpable authenticity. Banned, unbanned and now rightly regarded as a cult classic, the film was deeply influential in its authentic depiction of street life.

While *Pure Shit* offered a depiction of drug damaged twenty-somethings cruising inner city suburbs, *Redball* (Jon Hewitt, 1998) fo-

cused on the city's cops. In *Redball* the detectives are a swaggering gang, dangerous and menacing, often taking what they want in an endless circle of paybacks, bribes and extortion. As one protagonist bluntly states: 'Mate, we're cops, we can do anything we like.' Playing like an Antipodean rendering of James Ellroy's *LA Quartet* series the movie follows female homicide detective J. J. Wilson as she investigates the assault and murder of a number of children by a figure colloquially known as 'Mr Creep'. Against this already dark police procedural is the depiction of cops mired deep in utter corruption. Like Ellroy's *Black Dahlia* (1987), *Redball* mixes history and fiction, loosely drawing upon the still unsolved crimes of the figure named Mr Cruel by the Australian media and spinning these into a true vision of hell.

Reflecting the venality of the detectives, *Redball*'s Melbourne is a malevolent city, an abyss of bars, sex shops, strip clubs and neon streets, and again and again the churned muddy banks of the Yarra are awash with an all-enveloping charnel reek. Throughout the narrative a bloated corpse bumps downriver, its periodic discovery as it gets washed into the shallows is repeatedly ignored by cops who push it back into the swirling depths of water.

> **Crime is deeply embedded in the collective cultural memory of the country, and in Melbourne there is a long history of criminality, transgression, revenge and justice...**

When the body floats to the surface in the city centre, opposite the then newly constructed South Bank, officers once more consign it to the depths. Rot in the heart of the city.

The Melbourne of *Chopper* (Andrew Dominik, 2000) is a hyperreal roar that draws in part on the autobiographical stories written by Mark 'Chopper' Read across a slew of gleefully nihilistic paperbacks. *Chopper* follows the life of its titular antihero, in the gyre of violence that takes him from prison to freedom and back. While released, Read gravitates to his familiar St Kilda haunts, anxious to once more establish himself. But this beachfront suburb is no popular tourist locale but the background to brutality and crime, shot in sepias and reds in contrast to the cold blue hues of Melbourne's Pentridge Prison.

Finally, *Animal Kingdom* (David Michod, 2010), a film located deeper in the suburbs than other works detailed here. Now the recognizable Melbourne downtown has vanished into the horizon; this is pure suburbia, the zone in which the Australian Dream promises to become manifest. But *Animal Kingdom*'s protagonists, the criminal Cody family, are haunted by the endless spectre of police surveillance. Always watched by detectives the Codys are fighting for survival, their territory all-but reduced to the family home in which they bide their time, hoping to wait out those stalking them. The locales here are neither nightclubs nor semi-familiar inner city streets but local shops, small strip malls and the family house, but what was once the realization of the Australian Dream has for the Codys become both secluded cave and prison. The film obliquely references various Melbourne crimes and criminals, most clearly the notorious 1988 Walsh Street killings that saw two policemen shot in an ambush. Almost all iconographic traces of Melbourne have vanished in *Animal Kingdom*, yet its suburban location does not exist beyond temporality but within its own history of crime and retribution.

It is in the suburbs where events unfold, not the inner city, drawing, even loosely, upon Melbourne's history. In these hardboiled, naturalistic movies the city and its environs becomes a world in which a true darkness resides within the shadows from the bright sun. ✢

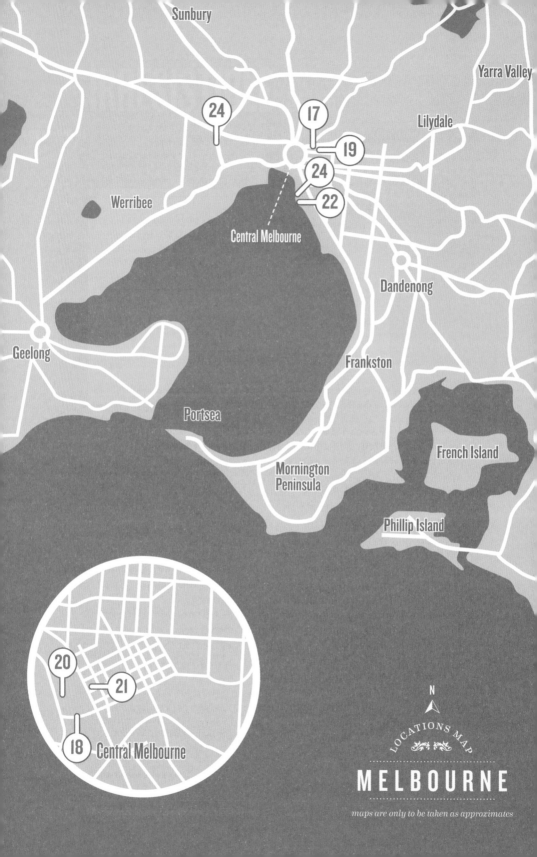

# MELBOURNE LOCATIONS

## SCENES 17-24

# THE CLUB (1980)

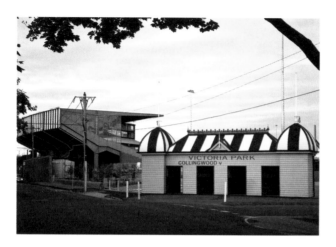

**THE CLUB, A CLASSIC** Australian sports film, captures the behind-the-scenes politics of a well-known AFL team at a time when professionalism was taking over the game. Battles are thick-and-fast between everyone from the coach to the administrator to the club's bright young star, all passionately voicing their opinions in all-or-nothing language. Despite its avoidance of a conventional trajectory, the film does capture the camaraderie and worship of the game, beginning with a confrontation between coach Laurie Holden (Jack Thompson) and club president Ted Parker (Graham Kennedy). After Laurie vocalizes his dissatisfaction with Ted to the media, the two agree to talk inside club grounds to resolve the matter. Meeting in the shadows of Victoria Park, the initially dark tone complements their icy relationship. Angered by Ted's recent actions, Laurie feels maligned by the club and specifically by Ted's rulings on football matters when he never played the game. As the pair make their way down the stands, light creeps onto them and their discussion loses its initial ferocity. Now bathed in bright sunlight, Ted explains his attachment to the club: he may not have played the game but he has watched almost every match since he was six – including Laurie's first game. As he replays Laurie's first kick on the oval with dodges and spins the audience realizes how important football is to everyone, not just the players. Ending with a slight reconciliation, the scene demonstrates the sport's ability to bring people of different social backgrounds together for one purpose. ➙*Julian Buckeridge*

(Photo © Amber Moriarty)

Directed by Bruce Beresford
Scene description: The 'fruitful' and 'harmonious' reconciliation
Timecode for scene: 0:32:44 – 0:35:53

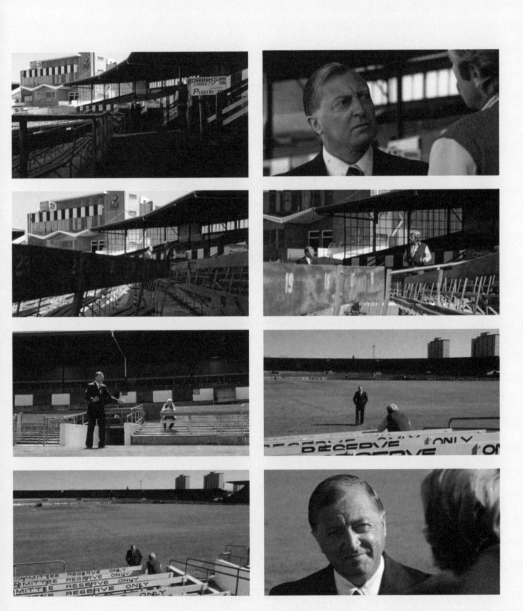

# THE PIRATE MOVIE (1982)

*Melbourne Maritime Museum/ Polly Woodside,*
*1-27 South Wharf Promenade, South Wharf, VIC 3006*

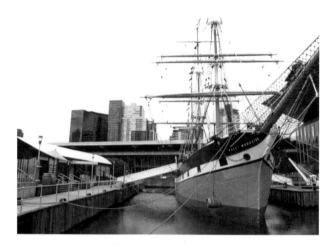

**KEN ANNAKIN'S** uniquely camp pirate musical begins with several shots of singing pirates aboard a fleet of intricately decorated pirate ships. However, all is not as it seems as these images are soon revealed as the closing credits of a Hollywood classic appearing on a television screen at the Melbourne Maritime Museum, run by the National Trust of Australia. A male voice commands, 'Well, that's how they did it in Hollywood with stars like Errol Flynn and Douglas Fairbanks.' And that must mean only one thing: if that was how they did it in Hollywood, the Australian way must be something different altogether. A sea of perfectly choreographed bikini-clad beauties move across the screen followed by Mabel (Kristy McNichol), a young, androgynous girl. She wears thick-rimmed glasses, jeans, and a plaid shirt and carries an oversized boom box. The beauties turn in unison to laugh at her. After stopping for a moment to grab an ice cream – 'pirate gold', the seller tells her – she soon follows the bikini girls toward a pirate ship – Melbourne's iconic Polly Woodside, the three masted, Belfast built Barque that sits in South Wharf – and continues aboard the vessel. Accordingly, this is where the surreal, pirate musical adventure begins. As a space away from the dull, drudgery of the everyday, Annakin positions the Melbourne Maritime Museum and the nearby Polly Woodside as a space teeming with treasures; a portal to both the fantastical past and the imagination. ↝ *Whitney Monaghan*

(Photo © Steve Davidson)

*Directed by Ken Annakin*
*Scene description: The pirate musical adventure begins*
*Timecode for scene: 0:02:50 – 0:06:00*

# SQUIZZY TAYLOR (1982)

*Studley Park, 1 Boathouse Road, Kew, VIC 3101*

**SET IN THE UNDERWORLD** of 1920s Melbourne, *Squizzy Taylor* is a film that slipped under the radar and remains in the archives, yet to be discovered by a new generation of gangster film aficionados. The uses of location in this film stunningly bring to life the story of an infamous Australian criminal. One location that stands out in particular is the well preserved Studley Park Hotel and rowing centre in the Melbourne suburb of Kew. Significantly, it is the only scene up until this point in the film that takes place outside of the dirty, grimy, inner city slums of Melbourne and Carlton. The elegance and beauty of the Kew riverside location is disorientating and so seemingly foreign to Squizzy's (David Atkins) otherwise dark and devious world. It is revealed that Squizzy is discreetly meeting with his journalist insider on the river, to sell more sensational stories to the press. Afterwards, whilst strolling by the riverside he runs into his old girlfriend Dolly (Jacki Weaver), who busts him with another woman. Dolly's commotion causes other people at the scene to recognize Squizzy and to shout 'That's Squizzy Taylor!' bringing to the forefront that the press spin has indeed been a success and Squizzy can no longer hide away in the shadows safe from the public eye. This scene acts as a turning point in the film, where Squizzy loses control over the form his fame has taken and he has become the notorious criminal, Squizzy Taylor. ❧*Yasmin Vought*

(Photo © Amber Moriarty)

*Directed by Kevin James Dobson*
*Scene description: The meeting on a rowboat with Squizzy's journalist*
*Timecode for scene: 0:50:33 – 0:51:59*

# MONKEY GRIP (1982)

LOCATION > *Bourke Street, Docklands, VIC 3008*

**WRITER AND SINGLE-MOTHER** Nora (Noni Hazlehurst) is walking down Bourke Street. She is occupied by her thoughts, and does not engage with the sights and sounds of the city's 'second street': the tram, buzzing traffic, colourful shops and noisy life on the street. She suffers due to her intense love for a young, <u>sensual actor</u>, Javo (Colin Friels). From the moment she saw him at the Fitzroy Baths, she knew she was in over her head. Nora is consumed by her passion for Javo, but Javo is consumed by his heroin addiction. They fell into bed quickly, even though Nora was with Martin (Tim Burns), a lost soul who frequently slept in her bed and who would always make bacon for her and her daughter Gracie (Alice Garner) in their sprawling share-house. Based on Helen Garner's grittier semi-autobiographical novel, the life of *Monkey Grip's* protagonist is echoed by her friends – artists, musicians and writers of grungy Carlton, circa the late 1970s. They are fired up by the excitement, lust and creativity of life figured out as it goes along, of doing a 'complicated dance to which the steps quite haven't been learnt'. But there is still a kind of emptiness and sadness here, the end days of Bohemia rapidly corroding. Apart from key scenes like Nora's walk down Bourke Street, the film was mostly shot in Sydney. But this detail barely matters given the film's visceral evocation of inner-suburban Melbourne, where even the light through the window feels like Melbourne. ➥***Kristina Gottschall***

(Photo © Steve Davidson)

*Directed by Ken Cameron*
*Scene description: Nora walks down Bourke Street*
*Timecode for scene: 0:40:58 – 0:41:39*

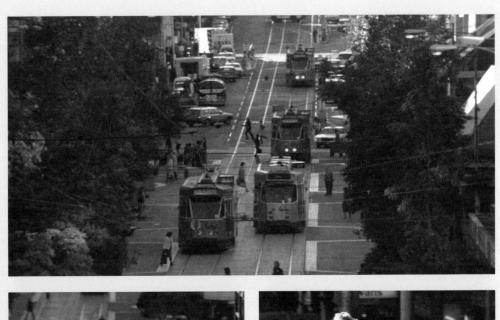

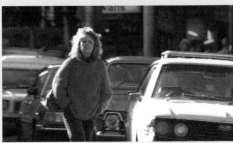

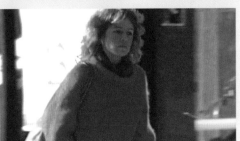

# MOVING OUT (1983)

*Train yard, Spencer Street Station
(now known as Southern Cross Station), Docklands, VIC 3008*

**SEVENTEEN-YEAR-OLD GINO** (Vince Colosimo) lives in a crowded terrace shared by two Italian immigrant families. Caught between the expectations of two cultures, Gino struggles to balance his Italian heritage with his desire to assimilate into the Australian way of life – 'After all, we're all new Aussies, some are just newer than others' he tells us. Skipping school, Gino and his friends find themselves at Melbourne's Spencer Street Station (now called Southern Cross), a place of hustle and bustle through which most of Victoria's regional and freight trains travel. However, director Michael Pattinson renders the train station surprisingly quiet in this striking scene where Gino and his friends aimlessly wander not the station itself, but the train yard. As a space that lies behind or beyond the busy train station, the train yard is hidden and almost invisible, an obvious parallel to the teenage experience. The teenage protagonists of *Moving Out* move freely through this space, literally occupying both the wrong and right side of the tracks. As they wander the train yard, one of Gino's friends steals a letter that he has been hiding and begins to read aloud, 'I'm writing to inform you that Gino is not progressing terribly well in English. He seems to be a bright boy but he doesn't work to his capacity.' These tracks come to signify a metaphorical fork in the road, as it is here that the troubled Gino must face both the implications of his poor behaviour at school and the expectations of his parents. **•• Whitney Monaghan**

(Photo © Steve Davidson)

*Directed by Michael Pattinson*
*Scene description: 'I'm writing to inform you that Gino is not progressing terribly well in English.'*
*Timecode for scene: 0:44:15 – 0:46:00*

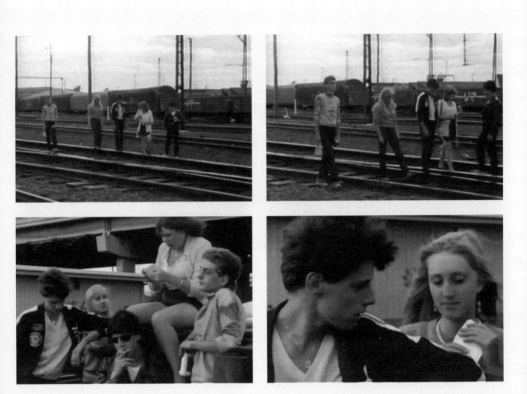

# MAN OF FLOWERS (1983)

*Point Ormond, Point Ormond Road, Elwood, VIC 3184*

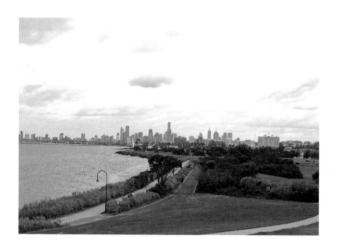

**CHARLES BREMER (NORMAN KAYE)** is a man at a distance from his world. The eccentric protagonist in Paul Cox's slow-burning, somewhat erotic portrait of loneliness and desire, Bremer seems ill-equipped for life in 1980s Melbourne. His is a cloistered, genteel, and curiously innocent existence that stands in stark contrast to the grubby, compromised, and slightly desperate lives of model Lisa (Alyson Best) and her druggie boyfriend. Cox uses the city landscape to draw out these differences. While Bremer lives on a verdant suburban street, taking refuge in the local church, Lisa walks cracked pavements along narrow inner-city thoroughfares, where the only flora is sprayed across brick walls. Drawn to beauty but unable to consummate his desire, Bremer eroticizes everything. There is as much pleasure to be found in a flower or a painting as there is in Lisa's naked body. It is as if being kept at a distance from desire – by his impotence – removes distinctions between the erotic and the non-erotic. If he can't have anything, he'll desire everything. The final scene, in which Bremer reaches the very edge of his world, seems to offer him a sense of release but little in the way of intimacy. Here is everything, free to be desired but unable to be touched. Those with a more rigid definition of the erotic might still find a thrill in retracing his steps. Point Ormond in St Kilda offers an impressive vista across Port Phillip Bay, where seagulls and kite-surfers twirl but rarely entangle and families trace the green shore in gangs of bicycles and roller-blades. ↬*Myke Bartlett*

(Photo © Amber Moriarty)

*Directed by Paul Cox*
*Filming location: Charles Bremer reaches the edge of the world*
*Timecode for scene: 1:26:41 – 1:29:07*

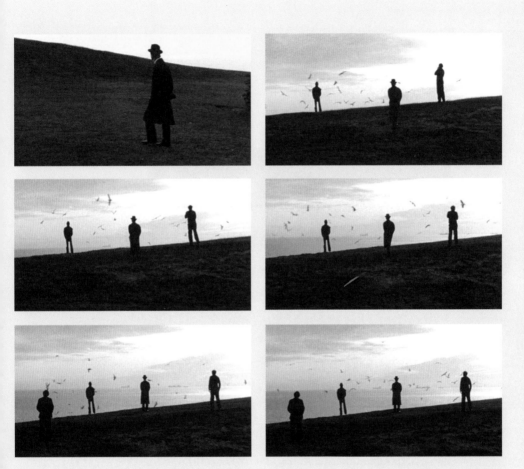

# BURKE AND WILLS (1985)

*Paddock in Kellyville, Sydney, NSW*

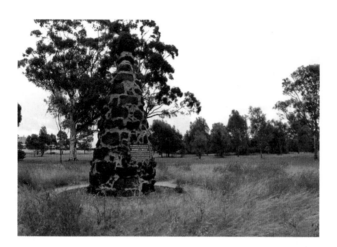

**IN THE SPIRIT OF** the famous explorers themselves, the producers of *Burke and Wills* went in search of a good many suitable locations to shoot the various parts of their recreation of the famous nineteen-man expedition of 1860 from Melbourne in the south to the Gulf of Carpenteria in the north. It was this location-shooting that was largely responsible for the inflated budget – at $8.9 million in 1984 it was the most expensive film ever made in Australia – and featured a mixture of authentic and stand-in locations. Darwin, Alice Springs, Cooper Creek, Mildura, Lake Torrens and Sydney were all used, and in the case of the early expedition departure sequence set in Melbourne's Royal Park, an empty cow paddock in the western suburb of Kellyville, Sydney was employed. This recreation, featuring crowds, camels and a military band, cost $250,000 alone to mount. The real Royal Park was designated as a reserve in the 1840s when Melbourne had a population of just a few thousand, so in 1860 when Burke and Wills took off on their expedition the park was still just bush land well outside the city. When the camels arrived for the expedition temporary stables were built, and the men employed on the expedition lived at the park for a couple of months while the expedition was assembled, hence it became the departure point. In 1890 a memorial was built in the park, and in 2010 a ceremony was held there to mark the 150th anniversary of the expedition's departure. **→Jez Conolly**

(Photo © Amber Moriarty)

*Directed by Graeme Clifford*
*Scene description: The great expedition departs from Royal Park*
*Timecode for scene: 0:04:49 – 0:09:07*

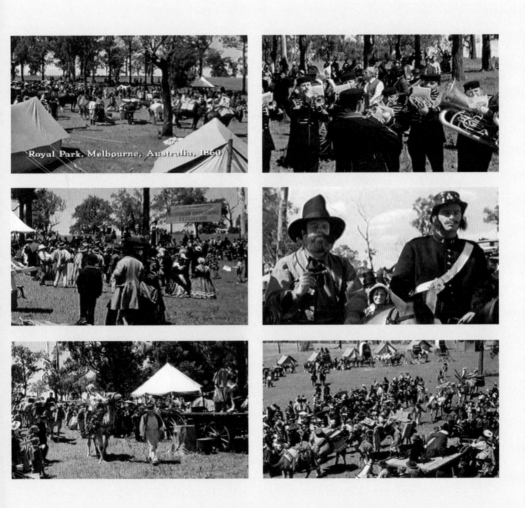

# DEATH OF A SOLDIER (1986)

*The Palais Theatre, Lower Esplanade, St Kilda, VIC 3182*

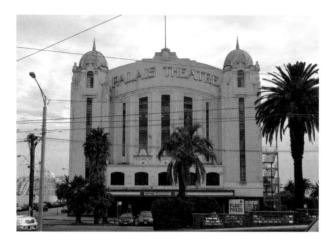

**THE PALAIS THEATRE** in St Kilda, the largest seated theatre in the country, has featured in a variety of films including Chris Lofven's *Oz – A Rock 'n' Roll Road Movie* (1976) and David Parker's *Hercules Returns* (1993). Part of St Kilda's leisure precinct, the current Palais Theatre, formerly a cinema and now exclusively a concert venue, opened its doors to the public in 1927. Noted for its art deco architecture and faux Egyptian and Baroque features, the Palais appears in a presaging early scene in Philippe Mora's World War II-era crime drama *Death of a Soldier*. Based on the real life crimes of US army Private Eddie Leonski (Reb Brown), a spree killer known as the Brownout Strangler, Mora's period piece highlights the tensions between the Australian and US military personnel (the latter stationed in the city during the war) that were exacerbated by Leonski's murderous activities. The partly fictionalized account of this dark incident in the city's history includes a sequence where James Coburn's Military lawyer, Major Patrick Dannenburg, latterly charged with defending Leonski in court, is seen leaving an Officer's ball held at the Palais. As the camera moves away from the Major, Leonski is seen hanging around outside the venue with another soldier. Symbolically positioned in front of a poster advertising the then recently released version of *Dr. Jekyll and Mr. Hyde* (Victor Fleming, 1941), the disturbed Leonski is only yards away from the man who would later try, and fail, to stave off his execution. ↝ *Neil Mitchell*

(Photo © Amber Moriarty)

*Directed by Philippe Mora*
Scene description: The Officer's Ball at the Palais Theatre
Timecode for scene: 0:08:55 – 0:10:34

 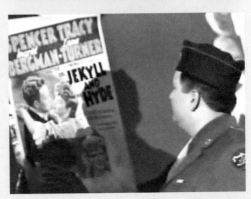

# A VIEW FROM THE WEST

Text by
LISA
FRENCH

*The Cinema of Ana Kokkinos*

THE CINEMA OF Melbourne film-maker Ana Kokkinos is deeply imbued with understandings and vistas of Melbourne's western suburbs. These personal filmic landscapes of the place she grew up offer an *insider's* view of place. Yet these insiders are also outsiders who are frequently 'Othered', painfully aware of their difference due to their sexuality (as gays or lesbians); their ethnicity (as Greek immigrants within a troubled multicultural Australia); their socio-economic status (as working class, and often disenfranchised youths); and their place as sons and daughters battling familial tensions (particularly as second generation migrants). Indeed, all these dilemmas are arguably expositions of her own background, and inform her vision as a film-maker who has achieved powerful insights into these worlds, creating a body of work that makes a significant contribution to representing Melbourne in the cinema.

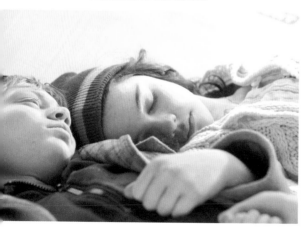

Each of her films has something to offer an understanding of this place. Her first film, the 1991 black-and-white short, *Antamasi*, began her filmic preoccupation with exploring Greek-Australian migrant life in Melbourne, with its large and vibrant Greek population. It also establishes her exposition of psychological landscapes, the inside of her characters. In 1994 she moved from the interior spaces (houses and backyards) of the earlier film to make *Only The Brave*, the production that first inserted the motif of looking from the industrialized west at the city, which in this film is used to underline the idea that her characters feel cut off from communities, families, and the action. She expanded this in *Head On* (1998), where the central protagonist, Ari (Alex Dimitriades), circles and approaches Melbourne across the mammoth West Gate Bridge, serving to signify the divide between the west and the centre. Through Ari's journey, the spaces of Melbourne and the west are mapped, and the urban experience is offered through the lens of teenage mobility, desire and angst. The film demonstrated her talent as a visceral and kinetic film-maker, a quality also evident in *The Book of Revelation* (2006), which has the most psychologically interior focus of all her films. In 2009, she directed *Blessed*, a collage of streetscapes, including views of the city from the west. Rachel Power describes it on the Australian Film Institute (AFI) website as 'like all Kokkinos's films', fiercely refusing 'to look away from the darkness that lurks in our cities and our hearts'.

*Head On* is arguably the Kokkinos film that has the most to say about Melbourne.

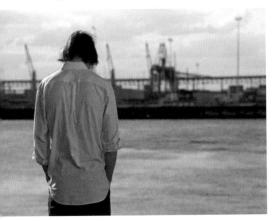

**Above** © 2006 Film Finance / Wildheart Zizani
**Opposite** © 2009 Blessed Film Productions / Film Victoria / Head Gear Films

Tracing Ari's movements through Melbourne over a 24-hour period, takes the audience through his head and body spaces (Ari's mind space, and the liminal, visceral space his body goes to); the physical spaces of the houses, the neighbourhood, the tram, the nightclub; and the migrant and diasporic spaces of the city through the ethnic locales, activities, sensibilities and conflicts.

Ari, a young, gay Greek, queers space and place as he cruises through the city imposing meaning on the urban landscape – ordinary locales such as the Vietnamese market become a 'gay beat'. Through referencing the Vietnamese diaspora, the market signifies Melbourne as a multicultural place, achieved through many scenes, such as Ari's arrival at the city centre. As he passes significant landmarks such as Flinders Street Station, he remarks that 'the place is full of Arabs'.

As he and his Greek friends pass the cake shops and foreign faces of the *mise-en-scène* that codes the inhabitants as ethnic 'Others', he yells racial abuse from the car window, a device used by Kokkinos to expose the city as a location for troubled multiculturalism.

In *The Book of Revelation* and *Blessed*, Kokkinos has moved closer to the inner city, and these films

## Kokkinos' vision of Melbourne explores the characters' lives from their ethnic, cultural, sexual and class difference.

are more centrally located there – as seen when Daniel (Tom Long) crosses the bridge over the Yarra into the midst of the city and then to the dim laneways of Melbourne in *The Book of Revelation*. This film sets up an opposition between gentrified Melbourne (signified by cafes and street performers), and the grunge of the west (contrasted by where the central character lives in each location). After his kidnap and rape, Daniel is dumped in the west like rubbish – signifying the west as a wasteland. In between the city and the west is Port Melbourne, a place where Daniel has moments of solace as he gazes out to sea. The port is an important location for migrants: the site of arrival and hope. It is also seen in the finale of *Head On*. Set against a backdrop of Greek music, and inter-cut with stills of migrants arriving at a sea-port (evoked through the editing as Melbourne), Ari's internal monologue allows the audience insights into what he has concluded from his journey: 'I am not going to make a difference. I am not going to change a thing. No one's going to remember me when I am dead,' which sounds bleak, but is an important concluding moment of self-acceptance.

*Blessed* tracks seven children roaming the streets of the city and suburbs over a 24-hour period (later recreating this time-frame from their mothers' perspectives). This film, like her others, foregrounds character types who are generally invisible, for instance Rhonda (Francis O'Connor), whose children end up on the streets and in care, and who is subjected to a string of violent partners. This may appear to be another bleak perspective, but Kokkinos has two aspirations: firstly, to realistically represent what for her is a disadvantaged part of *her* city (lacking infrastructure, and the dilapidated home to the socially underprivileged), and secondly, to tell a story about mothers and hope – all Rhonda has is the children she was 'blessed' with.

Kokkinos' vision of Melbourne explores the characters' lives from their ethnic, cultural, sexual and class difference, ultimately offering audiences an opportunity to also understand the city they see in her films from the inside as she takes them through the streets and suburbs, its landmarks, its interiors and its psyche. ✢

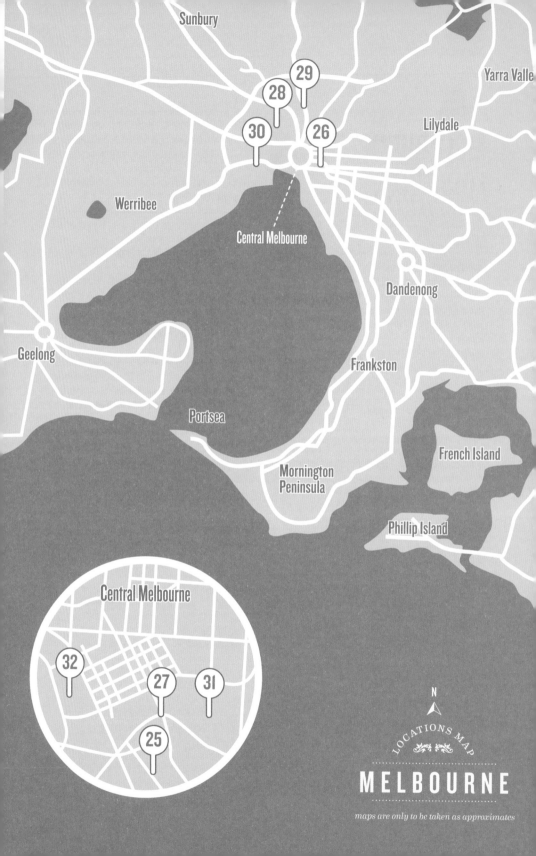

Sunbury

Yarra Valle

Lilydale

29

28

30  26

Werribee

Central Melbourne

Dandenong

Geelong

Frankston

Portsea

French Island

Mornington
Peninsula

Phillip Island

Central Melbourne

32

27  31

25

N

LOCATIONS MAP

MELBOURNE

maps are only to be taken as approximates

# MELBOURNE LOCATIONS

## SCENES 25-32

# MALCOLM (1986)

LOCATION

*The former South Melbourne Tram Depot, 209 Kingsway, South Melbourne, VIC 3205*

**THE OPENING SEQUENCE** of Nadia Tass' *Malcolm* is a masterclass in establishing location, character and tone. Tass' deft manipulation of three separate locations posing as one – the former South Melbourne Tram Depot on Kingsway, now the home of a BMW dealership – that bookend loveable man-child Malcolm's (Colin Friels) job-losing joyride around the Central Business District on his homemade model tram, also provides a celebratory portrayal of the city's most iconic method of transportation. A regular sight in Melbourne since 1885, the tram network is the largest urban tramway system in the world. Whilst the trams themselves are familiar to both residents and tourists, their resting places are more familiar to employees and hardened tram enthusiasts, of which Malcolm is both. The former South Melbourne Tram Depot is represented in the opening sequence by the former depot itself, a brief exterior shot of the depot in Kew and a scene-ending interior sequence filmed in the Preston Tramways workshop. For the audience, many Melburnians among them, the space portrayed is a singular tangible location, and the seamless blending of the various places used to portray the depot highlight the power of establishing location in audience's minds. With the Penguin Cafe Orchestra providing the soundtrack to Malcolm's career-ending escapade, Tass throws the viewer headlong into his offbeat, endearing world. In a bizarre case of life (virtually) imitating art, a tram obsessed teenage boy was arrested at gunpoint after stealing one and taking it for an unscheduled sojourn around the city in 2005. **◦▸Neil Mitchell**

(Photo © Steve Davidson)

*Directed by Nadia Tass*
*Scene description: Malcolm riding his homemade model tram*
*Timecode for scene: 0:00:00 – 0:04:50*

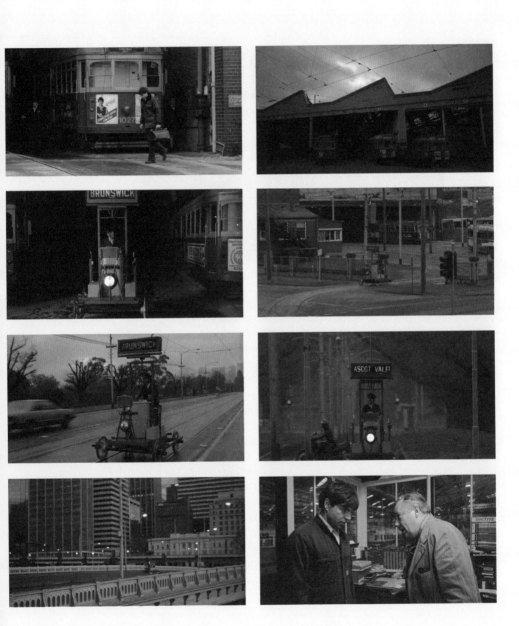

# DOGS IN SPACE (1986)

LOCATION *18 Berry Street, Richmond, VIC 3121*

**THE DEFINITIVE RECORD** of the Melbourne punk scene at the end of the 1970s, *Dogs in Space* is notable for its anarchic, plot-less progression from one bizarre vignette to another and for featuring the film debut of late INXS front-man Michael Hutchence. He plays Sammy, lead singer of the eponymous punk band whose members live, along with various oddball associates, in what would otherwise be a quiet house in the suburb of Richmond. When a young female activist tries to persuade Sammy to perform at a political benefit, he loses interest as soon as the music show *Countdown* appears on TV. The activist wanders into the kitchen, where a character credited only as 'Chainsaw man' sits caressing the item after which he is named. He begins a detailed monologue about his chainsaw and soon switches it on and waves it around, to the loud annoyance of those listening to the TV. The scene is inexplicable but entirely at home, both because it is in keeping with the rest of the film and because it is, apparently, exactly the kind of thing that used to occur at 18 Berry Street at the time the film is set: the house's occupants back then were *Dogs in Space* writer-director, Richard Lowenstein, and his friend, the Melburnian musician Sam Sejavka, on whom Hutchence's character is based. 18 Berry Street is, as it has always been, a private residence and is not open to the film's cult of followers. It attracts their attention nevertheless.
➖ *Scott Jordan Harris*

(Photo © Amber Moriarty)

*Directed by Richard Lowenstein*
**Scene description: A Chainsaw in the kitchen**
*Timecode for scene: 0:56:35 – 1:01:56*

# PROOF (1991)

*Hamer Hall, Victorian Arts Centre, 100 St Kilda Road, VIC 3006*

**JOCELYN MOORHOUSE'S** *Proof* relates the story of Martin (Hugo Weaving) who, blind since birth, pursues his quest for truth through his meticulous photography. This search for 'proof' places an unrealistic standards upon those around him – his housekeeper, Celia (Genevieve Picot), and Andy (Russell Crowe), a dishwasher at a local restaurant who describes the photos back to Martin. The film is dense and complex, exploring the ideas of friendship, trust and personal interaction. Despite Celia's warped relationship with both men, there is a key scene which paints her in a more sympathetic light. After blackmailing Martin into a secret night out, Celia leads him into a slowly-filling Hamer Hall. She makes a jibe about Martin's camera, aware that the events about to unfold could never be explained by a photograph – or even by Andy's description of it. Applause fills the Hall as the conductor makes his way to the stage. The audience falls silent as the orchestra bursts forth with Beethoven's Symphony no. 5. Martin is not only taken aback by this surprise but entirely moved, much to Celia's satisfaction. As the music continues, Celia cannot take her eyes off Martin who, overcome by the wall of sound, first takes off his glasses and then places his hand to his heart. Yet it is Celia who is reduced to tears, overcome by seeing the one she loves open up. While this happiness would be short-lived, it is the sound of Beethoven echoing across Hamer Hall that makes Martin reveal himself. **⚫Julian Buckeridge**

(Photo © Steve Davidson)

*Directed by Jocelyn Moorhouse*
*Scene description: The orchestral concert*
*Timecode for scene: 0:50:28 – 0:54:01*

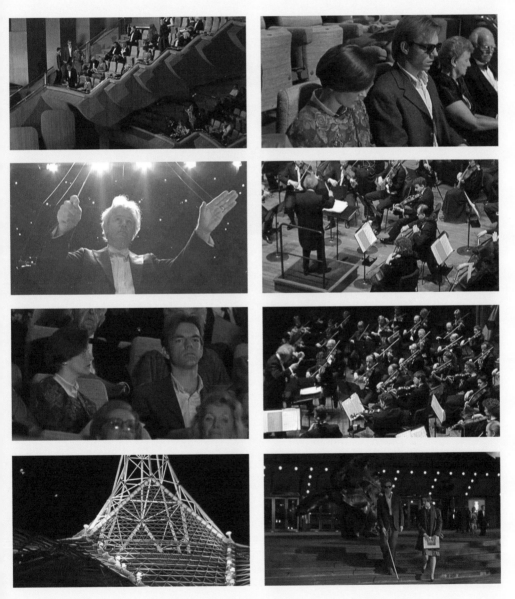

# HOLIDAYS ON THE RIVER YARRA (1991)

LOCATION *Maribyrnong Drive-In, Rosamond Road, Maribyrnong, VIC 3032*

**HOLIDAYS ON THE RIVER YARRA** is full of idiosyncratic views of urban and suburban Melbourne, highlighting such cinematically unused locations as stark, raised suburban train stations, the Olympic Park greyhound track, the West Coburg tram route, and the ramshackle industrial horizonality of the inner western suburbs. Leo Berkeley's feature debut is representative of a whole tradition of post-1950s inner-urban Melbourne cinema that emphasizes the suburban ugliness and iconic indistinctness of the city: Aleksi Vellis' *Nirvana Street Murder* (1991) and Phillip Adams and Brian Robinson's *Jack and Jill: A Postscript* (1970) amongst others. The film's title is itself ironic. The characters hardly ever see the Yarra, and dockland-bound industrial warehouses and the less fated Maribyrnong River dominate its intermittent vision of the city's waterways. One of the film's most resonant scenes features the central characters trying to sell spare car parts at the by then abandoned Maribyrnong Drive-in. Shot mostly in close-up and mid-shot, this scene emphasizes the relationship between the characters and the paltriness of their surroundings. This is one of many locations in the film that are no longer used for the purposes for which they were initially commissioned. In this regard, *Holidays* is something of a time capsule, capturing an already disappearing remnant of Australian suburban culture – the drive-in – at the point of its widespread (but not complete) demise. This small, intimate scene, ironically playing off the flipside of the dominant car culture and the everyday transformation of the stages of cinematic spectacle, is a peculiar and symptomatic vision of Melbourne. **↝ Adrian Danks**

(Photo © Amber Moriarty)

*Directed by Leo Berkeley*
**Scene description: 'The law of the jungle'**
**Timecode for scene: 0:41:07 – 0:44:04**

Images © 1991 Jungle Pictures

# DEATH IN BRUNSWICK (1991)

*The former Bombay Rock Club, corner of Phoenix Street and Sydney Road, Brunswick, VIC 3056*

**IN THE LATE 1970S/EARLY 1980S**, touring bands headed towards the Bombay Rock Club, a premier place for performing and recording. The BRC attracted eclectic music tastes and the 3 a.m. liquor license pulled all sorts, trumping the midnight shut down of neighbouring pubs. The BRC's reputation was hardened by a string of violent incidents that occurred there, culminating in a dramatic end when it burnt down in the mid-1990s. *Death in Brunswick*'s tight-jeaned protagonist Carl (Sam Neill) is living a life with plenty of booze but no direction. He picks up casual work as a chef at the BRC. The owners are thugs who sexually harass lip-glossed bar girls, brutalize ill-fated Turkish chef assistant Moustafa 'the Wog' (Nick Lathouris), and immediately begin to taunt softly spoken hipster Carl, the 'Cookie'. Cookie is yanked into their crazy world and is quickly an enemy to hardened criminals and an accomplice to Moustafa's murder (the death in Brunswick). In one crucial scene, Turkish enemies of the Greek owners hurl a fire bomb at the BRC from a car on Sydney Road and speed away, leaving Carl to be blamed. But the film is a fun tribute to the rough and tumble of Brunswick, rather than anything sinister. Even peace on the weather-beaten streets is restored in a tongue-in-cheek way. Carl gears up for a more domestic and conventional facet of Brunswick life: marrying the gregarious Greek-Australian Sophie (Zoe Carides). ↝***Emma Jane McNicol***

(Photo © Amber Moriarty)

*Directed by John Ruane*
**Scene description: The club gets fire-bombed**
**Timecode for scene: 1:05:26 – 1:07:58**

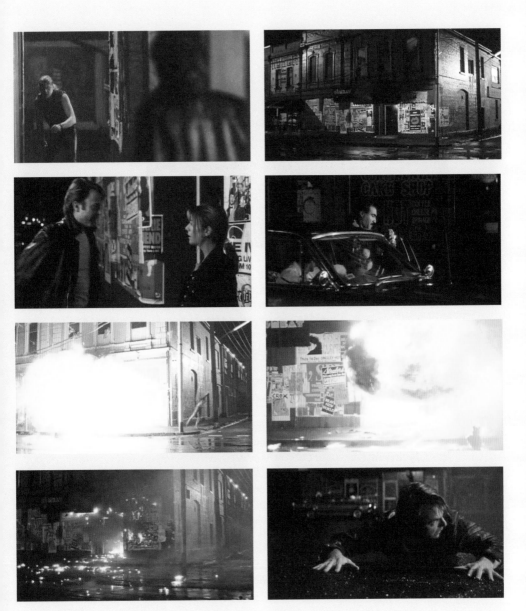

Images © 1991 Australian Film Finance Corporation (AFFC) / Film Victoria

# SPOTSWOOD (1992)

LOCATION *Spotswood Refineries, Spotswood, VIC*

**MARK JOFFE'S SPOTSWOOD** is set and shot in the overcast surrounds of Melbourne's western suburbs. The year is 1966 and Anthony Hopkins' efficiency expert is on a mission to cut staff and slash the budget of a moccasin factory in Spotswood, an area known less for its serene beauty than its close proximity to bayside refineries. These rarely filmed locales, some 7 km out from Melbourne's CBD, under the shadow of the West Gate Bridge, are lovingly presented by Joffe in a quaint and nostalgic manner. The classical architecture of the area helps accentuate the film's personal tale of youthful coming of age, which was a common theme of many Australian films that found success around the world in the early 1990s. In this short, but lovely, sequence Wendy (Toni Collette) takes her neighbour, co-worker, and secret object of affection Carey (Ben Mendelsohn) to the local docks. As they bike down the windswept pier and then row across the murky waters of the Yarra River, Wendy and Carey discuss the new girl at work who claims to be a fashion model. On the cusp of adulthood, Wendy's crush threatens their lifelong friendship whilst Carey remains oblivious. There is a sweetness to this scene, however, as Wendy and Carey find a brief moment of beauty against the typically ugly scenery of the refineries, gusts of factory smoke and swarming seagulls. The unique charm of the less-developed western suburbs are just right for Joffe's film about a community stuck in the past. ❖ **Glenn Dunks**

(Photo © Steve Davidson)

*Directed by Mark Joffe*
**Scene description: Carey and Wendy discuss Carey's lovelife**
**Timecode for scene: 0:18:45 – 0:20:09**

# ROMPER STOMPER (1992)

LOCATION *Richmond Railway Station, VIC 3121*

**THE FIRST SCENE OF** *Romper Stomper* announces the film's intentions, and those of its central characters, with sickening force. The unsettling score that plays over the opening credits is replaced by the sound of a skateboard's rolling wheels and the carefree chatter of two young men and a woman. Crucially, though, their chatter is not in English. As the group glides down a ramp and into a dark underpass – the walls and tarmac wetted to better reflect light in an old cinematographer's trick – they pass an unsavoury selection of skinheads. The skateboarders' crime is that they are Asian immigrants and thus, to the neo-Nazi's led by Russell Crowe's Hando, not Australian. We, and the immigrants, know that something awful will soon ensue, and the violence that erupts is as much an assault on the audience as on them. From its first seconds, Romper Stomper tells us it is an uncomfortable Australian film about an issue that makes Australia uncomfortable. The decision to announce onscreen that the scene is set and shot in Footscray Station is inspired: it screams that this is a real Melbourne scene in a real Melbourne place about a real Melbourne problem. But, as often in the movies, what appears onscreen is not an accurate reflection of the real-life location it supposedly shows. The scene may be set at Footscray Station, but it was not shot there: Footscray does not have an underpass, dark or otherwise, and so the one at Melbourne's Richmond Station was used instead. ◆**Scott Jordan Harris**

(Photo © Amber Moriarty)

*Directed by Geoffrey Wright*
*Scene description: 'This is not your country'*
*Timecode for scene: 0:00:52 – 0:03:19*

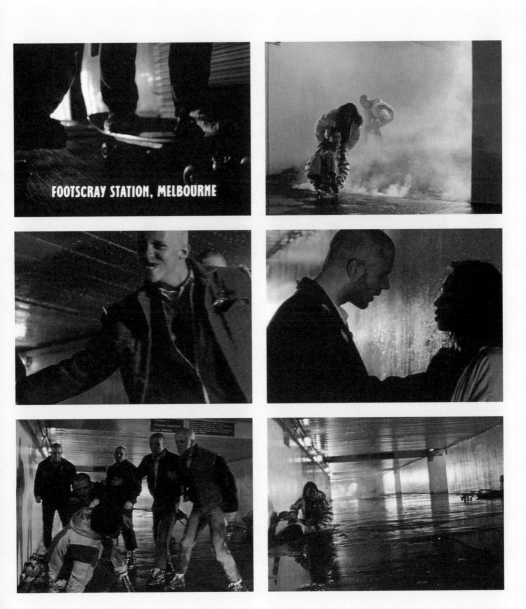

# METAL SKIN (1994)

LOCATION *Site of the Etihad Stadium, Docklands, VIC 3008*

**BLOOD-SPLATTERED AND** catatonic with fear, Roslyn (Nadine Garner) walks dazed and disoriented through a maze of shipping containers made otherworldly in the early morning blue light. She has just escaped a furious and bloody car chase. It is not the first time she has been nearly obliterated by the violent games of reckless young men and she has the scars to prove it. Local boy Joe (Aidan Young) has finally blown a gasket and purses Roslyn and her boyfriend Dazey (Ben Mendelsohn) in their suped-up Charger. The high-powered masculine machines of destruction reach speeds of 190 km as they fly along the local roads, the changing gears shrieking as they go. Seizing her chance to get out of the car when it stalls, Roslyn makes her escape under gun fire from Joe who yells that Dazey doesn't deserve her love. Switching mode from 'hunted' to 'hunter', Dazey rams Joe off a raised platform to his death, and hobbles over to his mangled remains to chant, 'I beat you, I beat you'. Aimlessly walking, Roslyn stares at the sky. Panning up out of the stacks of containers, now the site of the Etihad Stadium, the camera moves across to the city skyline. The credits roll. Dark, both metaphorically and literally, Geoffrey Wright's film explores the themes of hopelessness, failure and loss through the tortured and desperate lives of a group of youths from the blue-collar suburb of Altona. A nightmarish hyper-real ride, visceral and bleak – it is Melbourne, but not as we know it. ⇢*Kristina Gottschall*

(Photo © Amber Moriarty)

*Directed by Geoffrey Wright*
Scene description: Roslyn walks dazed and disoriented through the shipping yards
Timecode for scene: 1:41:47 – 1:47:44

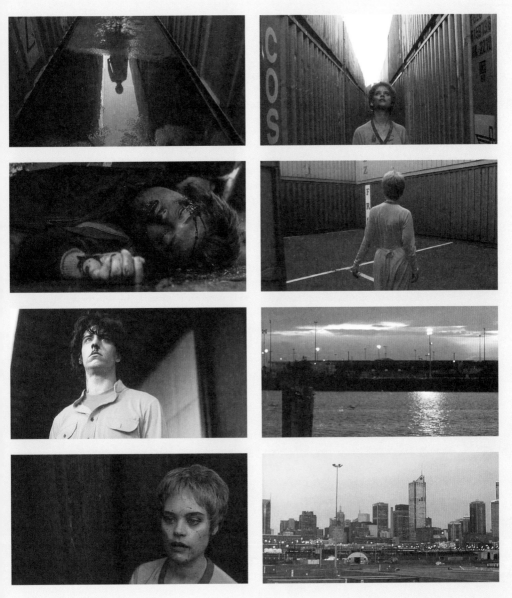

# SPORTING MELBOURNE

*Centre of a Nation's Obsession*

Text by
JULIAN
BUCKERIDGE

**IT IS UNSURPRISING** that Melbourne is known as the sporting capital of Australia. Boasting one of the four tennis Grand Slams, a stage of the Formula One Grand Prix, Masters events in golf, half the teams in the AFL, the Boxing Day test series, the highest attendances in the A-League, and the host of 'the race that stops a nation', sport captures the spirit of the Melbourne public. This passion translates into art, with the new Basil Sellers Art Prize encouraging artists to explore sporting culture. Australians connect sport with everything from personal achievement to historical controversies, to globalization and community life. Just like other Melbourne films, sport is constructed around the themes of the bleak, the suburban, the strange and the underdog.

The Melbourne Cup is the most directly documented sporting event in Australian cinema and was recorded in one of the nation's earliest surviving films, *Melbourne Cup 1896* (Marius Sestier, 1896). Shot using a Lumiere Cinématographe, the film is one of the first Australian films to present a story using footage in chronological order, and showcased the large crowd waving their

hats at the then foreign camera. *The Bulletin* magazine found it 'beautifully appropriate that the first Australian picture presented by the new machine should be a horse race'. This documentation of the Melbourne Cup would continue through the twentieth century, with the *Australasian Gazette – 1924 Melbourne Cup* (1924), which included footage of a huge crowd as well as the feature race, won by Backwood. Yet it would be another horse that would inspire multiple narrative features. In the four years of his career, Phar Lap would win 37 out of 51 races, including the 1930 Melbourne Cup. Three films, *A Ticket in Tatts* (Frank W. Thring, 1934), *Thoroughbred* (Ken G. Hall, 1936)) and *Phar Lap* (Simon Wincer, 1983) were heavily inspired by the real events – notably the attempt to kill the horse before the Melbourne Cup. Both *A Ticket in Tatts* and *Thoroughbred* would focus on the criminal aspects of horse racing, which was highly publicized at the time. *The Argus* newspaper report of the attempted shooting of *Phar Lap* on 3 November 1930 read,

------------------------------------------------------------

*It is not unusual for a hot favourite for an important race to receive ill-treatment at the hands of miscreants apparently in the employ of some person or persons who would suffer heavy financial loss in the event of the favourite proving successful.*

------------------------------------------------------------

A Ticket in Tatts and Thoroughbred were narratively similar, with a young and somewhat naive boy protecting a horse from an international crime syndicate who want it killed on Melbourne Cup Day. While the latter film was accused of plagiarizing Frank Capra's *Broadway Bill* (1934), both drew inspiration from Phar Lap's career and the formation of organized crime due to the Depression. Crime associated with horse racing would continue to be represented in cinema, including Scott

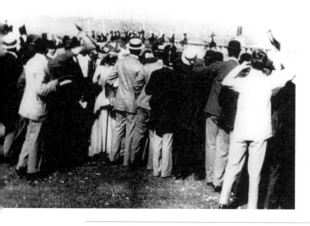

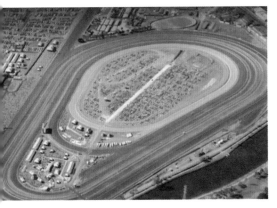

Roberts' *The Hard Word* (2002), a reworking of a real crime, 'The Great Bookie Robbery' on 21 April 1976, where six to twelve million dollars was stolen from the Victoria Club. *The Hard Word* is indicative of the bleakness explored in late twentieth to early twenty-first century Australian film and, combined with the dark criminal landscape of the 1970s and 1980s, highlighted the underworld presence in racing seventy years on from *A Ticket in Tatts*.

Yet Melbourne cinema has not solely focused on the bleak side of sporting history. Australia has always used sport as a way for the nation to capture international attention. Sport is worshipped, particularly in Melbourne, where the underdog, or maligned suburban figure, can rise to mythological levels. Wincer's *Phar Lap* (1983) and *The Cup* (2011) encapsulate the adulation of two inspiring horses: the former the titular thoroughbred, the latter Media Puzzle, which won the 2002 Melbourne Cup. Both starring Tom Burlinson, the features glamorize racing and the incredible creatures that glide across the track. Both tell of figures hindered by an incredible number of obstacles but still managing to find success and retribution. Magically charged at many moments, the films explore how racing galvanizes the city. Still, Melbourne is not a one-sport

town. It is well recognized that the Melbourne Cricket Ground is the city's spiritual home – at least for most. Originally an Aboriginal (Kulin clan) camping ground in 1844, successive waves of city development forced the Kulins off the land and they were replaced by a playing field that would eventually lead to a 100,000 people roaring with pure tribalism on the Australian Football League's (AFL) Grand Final Day. Territorialization and suburban loyalties are the big themes with AFL football, but so is its popularity. Even in *The Cup*, a film about horse racing, Australian Rules Football is a key player in the lives of the Oliver brothers – even boys from Perth visiting for work make the journey to Etihad Stadium to watch the indigenous sport.

The AFL films, however, demonstrate the suburbs struggle to survive against the code's movement to professionalism and the dominance of Melbourne teams over country Victoria. David Baker's *The Great MacArthy* (1975) centres around a country footballer kidnapped to play in the Victorian Football League (VFL) for South Melbourne. Conducting amorous affairs with a secretary, a teacher, and the coach's daughter, the footballer is slowly corrupted from an innocent and skilled player to a party boy.

*The Club* (Bruce Beresford, 1980) also follows a suburban club battling issues associated with burgeoning professionalism in what was becoming a national sport, as corrupt managers controlled the VFL team. Much like *The Great MacArthy*, it follows a predictable narrative with an uplifting ending. Still, it differs by offering viewers an insight into why the sport is so popular in Melbourne: it brings people of different social backgrounds together for a sole purpose – a special, shared goal.

As Albert Camus, Nobel Prize laureate, once said, 'After many years, during which I saw many things, what I know most surely about morality and the duty of man I owe to sport'. So from the documentation of *Melbourne Cup 1896* to *The Hard Word*'s bleak insights, and from The Cup's inspirational tale to *The Castle*'s (Rob Sitch, 1997) brief reference to greyhound racing, to *Falling for Sahara*'s (Khoa Do, 2011) discussion of AFL in refugee life, sport encapsulates the best and worst of Melbourne. ✛

**Sport is worshipped, particularly in Melbourne, where the underdog, or maligned suburban figure, can rise to mythological levels.**

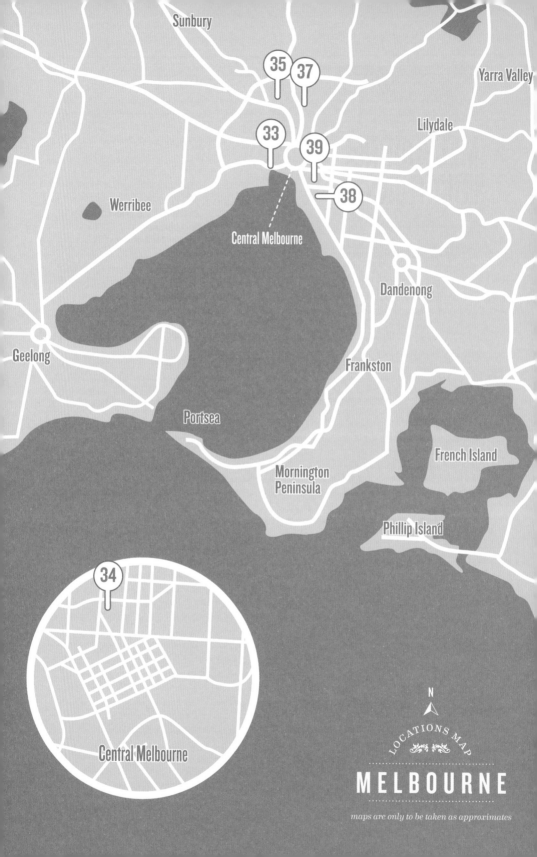

# MELBOURNE LOCATIONS

## SCENES 33-39

# ANGEL BABY (1995)

*West Gate Bridge, Port Melbourne, VIC*

**ANGEL BABY IMMERSES** us in the unstable world of lovers Kate (Jacqueline McKenzie) and Harry (John Lynch) who meet as patients at a mental health clinic. They wander together through the city, the actual geography of the streets giving way to the particular logic of Kate's schizophrenia: bridges and pathways, buses and underpasses, all have the potential to be sites of both salvation and terror. Kate's only certainty is her faith in the messages transmitted to her by the phrases spelt out on TV's 'Wheel of Fortune'. As the couple falls passionately in love, they feel empowered and invincible. Strong performances by the entire cast and sympathetic direction by Michael Rymer create a tender, fragile drama of *amour fou*, a rare achievement in Australian cinema. When Kate becomes pregnant, they face pressure to abort from social workers and family. Kate and Harry walk to the top of the Westgate Bridge, notorious as both a suicide point and for the tragic accident that occurred during its construction in 1970, in which a section collapsed and 35 workers lost their lives. Determined to keep the child, Kate spreads her arms and calls like a bird, soaring above her troubles. However their happiness is short lived as Kate's pregnancy prompts the pair to give up their medication, and their lives unravel. The child is born but Kate does not survive, and in the closing moments of the film Harry returns to the Westgate, summoning the memory of Kate's joyful gesture as a bridge to his own future.
**➡ Fiona Trigg**

(Photo © Steve Davidson)

*Directed by Michael Rymer*
Scene description: Harry has a vision of Kate on the Westgate Bridge
Timecode for scene: 1:34:53 – 1:37:18

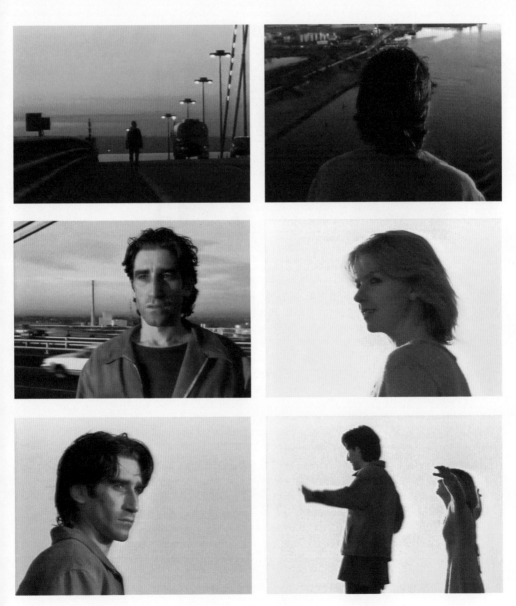

# LOVE AND OTHER CATASTROPHES (1996)

LOCATION *Parkville Campus, University of Melbourne, VIC 3010*

**EMMA-KATE CROGHAN'S** unique comedy, *Love and Other Catastrophes*, follows five students as they make their way through the trials and tribulations of a single day on Melbourne University's Parkville Campus, one of its several campus sites. Founded in 1853, The University of Melbourne, is the oldest in Victoria and, after the University of Sydney, the second oldest in Australia. Mia (Frances O'Connor) wants to prevent her girlfriend Danni (Radha Mitchell) from moving in with her and changes departments at university because she is obsessed with her lecturer. Alice (Alice Garner) seeks the perfect boyfriend whilst avoiding her thesis supervisor because her thesis is four years overdue. She soon finds herself with a crush on part-time Classics student, part-time gigolo, Ari (Matthew Dyktynski). Shy medical student Michael (Matt Day) rounds off the group. His day is spent searching for a new home and falling in love. As the end of the day approaches, Mia frantically runs back and forth between two university departments so that she can transfer to a different class, Michael and Ari discuss the complexities of relationships, and Alice manically avoids her supervisor. As each of the characters stumble into the lives of the others, Melbourne University is positioned as both a space of frustrating bureaucracy but also a utopian space through which people from all different walks of life meet, engage in conversation, challenge one another, fall in love and become friends.
**↝ Whitney Monaghan**

(Photo © Steve Davidson)

*Directed by Emma-Kate Croghan*
*Scene description: 'I won't sign it until the head of that other department signs it.'*
*Timecode for scene: 0:21.40 – 0:28.13*

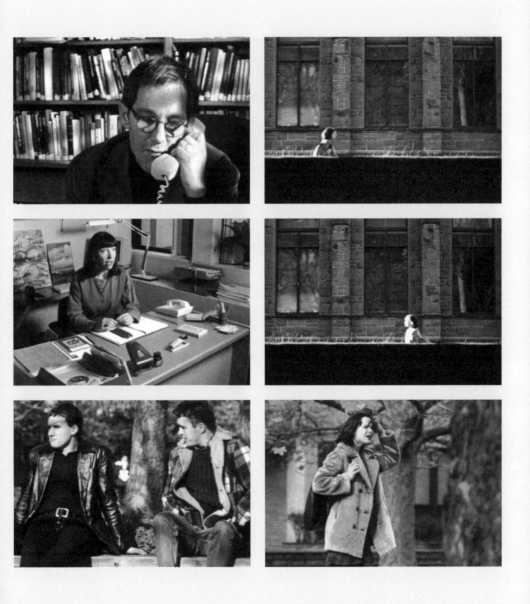

# THE CASTLE (1997)

LOCATION *3 Dagonet Street, Strathmore, VIC 3041*

**THE KERRIGAN FAMILY** live at 3 Highview Crescent, Coolaroo, in a cosy little home they call their Castle. Their 'serenity' is disturbed when the government threaten to seize their house from underneath them to extend the nearby airport. The family fight back, in what becomes a land rights case similar to the real land rights movement fought by the Australian Aborigines. Coolaroo is a mythical suburb, the actual house is located in the Melbourne suburb of Strathmore, which is next to Essendon airport. However, some of the airport footage was shot at the neighbouring Tullamarine (Melbourne) airport, the second busiest airport in Australia. The establishing scene of *The Castle* displays the close proximity of the house to the airport and introduces a few key features of the household, including the greyhound house, the pool room, the power lines surrounding the house, and the impending extensions in the airfield-facing backyard. The intentionally tacky aesthetics of the Kerrigan home are married with moments of warmth and love between the characters, setting the emotional tone for the film's subject matter which tackles the issue of basic human rights to property, regardless of how unsightly and lacklustre that property may appear to an observer. 'The Castle' as a character symbolizes a dramatized portrayal of Melbourne suburban cultural heritage that could have come across as denigrating to the broader Australian public, had it not been for the well-crafted use of cringe worthy family humour and a relatable, heart-warming premise. •➤ *Yasmin Vought*

(Photo © Amber Moriarty)

*Directed by Rob Sitch*
*Scene description: Introducing the Kerrigan family and their 'Castle'*
*Timecode for scene: 0:00:42 – 0:08:50*

Images © 1997 Working Dog / Village Roadshow Entertainment

# HEAD ON (1998)

LOCATION *Silver Top Taxi number 4337 across the city*

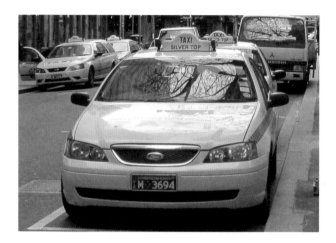

**HEAD ON,** Ana Kokkinos' provocative vision of cultural, sexual and generational clashes, seen through they eyes of gay, 19-year-old Greek Australian Ari (Alex Demitriades), covers 24 hours in his hedonistic, confrontational and emotionally angst ridden life. Kokkinos' adaptation of Christos Tsiolkas' 1995 novel Loaded also places great emphasis on Ari's physical journey around the culturally diverse urban environment, in his quest for sexual gratification and some kind of emotional succor. In one evocative five minute sequence Ari and transvestite Johnny (Paul Capsis), in full drag and going under the name of Toula, catch a Silver Top Taxi from the north of the city in the direction of what was then the Three Faces Nightclub on Commercial Road to the south. Ari and Toula crack jokes, share a joint, and listen to Greek music with their Turkish driver (Costas Kilias) whilst taking a detour into Coburg so Ari can check up on his sister and her Lebanese boyfriend, before a run-in with the police brings their journey to a premature end. Founded in 1936 to 'provide a premium transport service to the city's socialites' Silver Top Taxis, with their distinctive yellow cars, are as much a part of Melbourne's iconography as its fixed locations. Along with the city's train, tram and bus services, Silver Top Taxis are a vital cog in Melbourne's machinery, and the taxi in *Head On* takes its passengers and the viewer on a whistle-stop tour through the city's shape shifting, multicultural make up. **↦Neil Mitchell**

(Photo © David Collyer)

*Directed by Ana Kokkinos*
**Scene description: Taxi ride to trouble**
**Timecode for scene: 1:13:04 – 1:18:43**

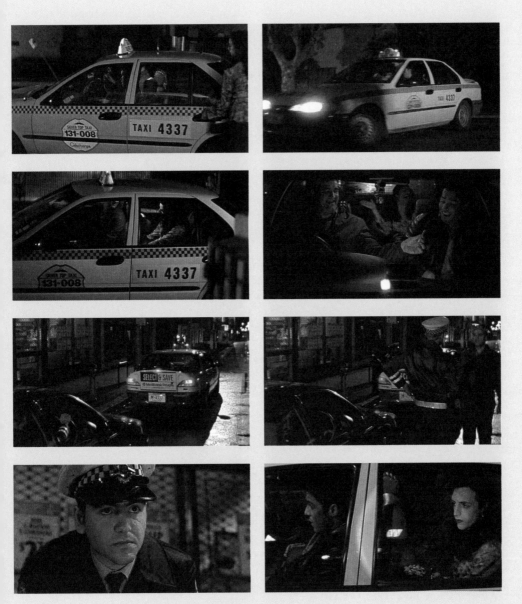

Images © 1998 Australian Film Finance Corporation (AFFC) / Film Victoria

# CHOPPER (2000)

LOCATION *Pentridge Prison, 10 Champ Street, Coburg, VIC 3058*

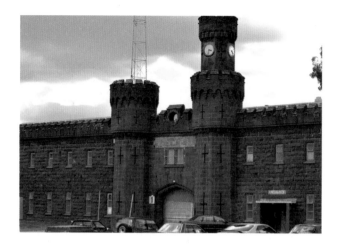

**MELBOURNE'S PENTRIDGE PRISON** was built in the 1850s, in the cold tradition of the English Penitentiary system. Andrew Dominik's *Chopper* opens with notorious Aussie criminal, Mark 'Chopper' Read (Eric Bana) being interviewed on television. The camera pans back to reveal Chopper in his private Pentridge cell, chuckling as he watches his own image on the television screen. The presence of 'multiple Choppers' in this scene is important. One Chopper sits in his cell, watching another version of himself in the liminal space of television. But neither are the 'real' Chopper. At the time of the film's release, the 'real' Chopper was walking the streets, fame hungry and franchising. 'Real' Chopper's menacing freedom at the time provided the film just enough gritty realism to be an instant cult hit. In this tradition of thought, director Andrew Dominik understood the importance of fighting to use the 'real' Pentridge as his location. As the credits roll, Dominik surveys the old establishment through the eyes of the modern, media-savvy generation. The camera, poised just at the jail's boundaries, sets a vivid blue sky against the old stone. Clouds zoom by with hyperbolic speed. Cole Porter's nostalgic tune teases '... Don't Fence Me In'. Irony and pop music gloss over the institution. Dominik's film portrays the triumph of Reed against the Pentridge system, which failed to properly confine, let alone, rehabilitate him. As a prison the space is no longer in use, and instead houses citizens of Coburg in an apartment block. **➥Emma Jane McNicol**

(Photo © Amber Moriarty)

*Directed by Andrew Dominik*
**Scene description: 'I'm a bloody freak show'**
*Timecode for scene: 0:00:18 – 0:03:40*

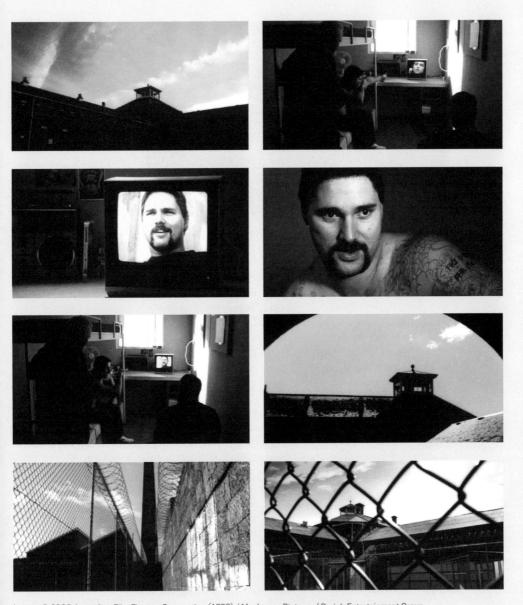

Images © 2000 Australian Film Finance Corporation (AFFC) / Mushroom Pictures / Pariah Entertainment Group

# THE BANK (2001)

**CORPORATE THRILLERS** are uncommon fare for Australian film-makers, with Robert Connolly's *The Bank* a rare Antipodean specimen in the genre. Connolly's directorial debut delves into the realm of American offerings *Wall Street* (Oliver Stone, 1987) and *Glengarry Glen Ross* (James Foley, 1992) in examining the impact of the business world on those ensconced within its web. As the title intimates, finance is the topic at hand, as idealistic mathematician Jim Doyle (David Wenham) joins the ranks of fictional banking institution Centabank. Recruited by unscrupulous chief executive Simon O'Reily (Anthony LaPaglia) for his stock market predicting formula, he is soon faced with an ethical quandary, with O'Reily's method of making money a moral grey area. Accompanied by fellow employee and romantic interest Michelle Roberts (Sibylla Budd), Jim attends a party at O'Reily's stately house. Amidst the fun and frenzy of the celebrations, a confrontation occurs that demonstrates the first signs of sinister happenings beneath the surface of their working relationship. The incident illustrates the vast chasm between the two men in terms of lifestyle and principles, with the sprawling mansion filled with the city's society set perfectly placed as the symbol of difference. Restored Melbourne landmark Rippon Lea house, built as a family home in 1868 and now in the hands of the National Trusts of Australia, provides the setting for the pivotal scene, with its inclusion utilizing the history of the spectacular property to further demonstrate the luxurious world of the ruthless antagonist, and the epitome of his greed fuelled antics in search of wealth and status. ↪*Sarah Ward*

(Photo © Amber Moriarty)

*Directed by Robert Connolly*
Scene description: *Jim and Michelle arrive at Centabank CEO Simon O'Reilly's party*
Timecode for scene: *0:40:53 – 0:44:14*

# CRACKERJACK (2002)

LOCATION *Melbourne Bowling Club, 138 Union Street, Windsor, VIC 3181*

**THE FIRST SCENE** in which the obnoxious Jack (Mick Molloy) is introduced to the senior members of Cityside Bowling Club, familiarizes the audience with the aesthetic distinctiveness of the bowling green setting in which the majority of *Crackerjack*'s action will take place. It also sets up the relationship dynamics of the core characters through light-hearted Australian style slapstick comedy. 'Mateship', the notion of 'a fair go' and the role of sports in the development of personality are popular Australian stereotypes used in this scene to conjure up emotion. This is achieved through utilizing the generational gap between Jack and the older members of the club, and subtle references to the notion of integrity in the context of the bowling green. In the words of Stan (Bill Hunter), bowls is a 'true revealer of character'. This particular scene was filmed entirely on location at Melbourne Bowling Club in the inner city suburb of Windsor. The choice of natural lighting, traditional decor, use of a genuine Bowling Green, and minimal props adds to the placement of the characters at a contemporary bowling club in downtown Melbourne. Although at first glance, 'Cityside Bowling Club' could be any bowling club in Australia, the use of signage and background landscape shots of terrace houses and architecture presents a streetscape that is characteristically Melburnian in style. The decision to maintain the setting of *Crackerjack* on location in an existing Melbourne bowling club reinforces the audience's perception of place and helps to lure them into the narrative flow. ⟿ *Yasmin Vought*

(Photo © Amber Moriarty)

*Directed by Paul Moloney*
*Scene description: Jack's first bowling game at Cityside Bowling Club*
*Timecode for scene: 0:07:47–0:11:40*

# STANLEY'S SHADOW

## Central Melbourne's Business District

Text by
DEAN
BRANDUM

**THERE WAS AVA GARDNER,** running to catch a Frankston train from Flinders Street station! The studio-era Hollywood glamour of Gardner, Peck, Astaire, and Perkins wandering through Melbourne in *On the Beach* (Stanley Kramer, 1959), and its laboriously related end-of-the-world narrative, made an impact on us all. For we saw the world's last moments: a deserted Elizabeth Street, trams ground to a halt in Swanston Street, and the final shot of the State Library, anti-nuclear pamphlets blowing in the wind. *On the Beach* captured a (mostly) pre-modernist Melbourne, one of decaying Victorian-Edwardian-era architecture and skylines uninterrupted by the post-war philosophy to build upwards, that would not infect Melbourne until the 1960s. Indeed, the geography remains the same, but other than the most notable of structures, the streetscape of *On the Beach* bears little resemblance to the Melbourne of today.

Although Melbourne had once been a hive of film-making activity, the local industry had been moribund for many years until Stanley Kramer and his crew arrived, and their capturing of the city in

its monochrome, near-apocalyptic glory, set a template for the depicting of Melbourne while simultaneously becoming a burden for those film-makers who followed. In fact, it would take more than a decade for another feature film to be made there.

Melbourne's cityscape had changed dramatically by the 1970s, as is evidenced by *Alvin Purple* (Tim Burstall, 1974), when the titular character strolls around a rain-soaked Bourke Street at night in a montage of contemplation to a Brian Cadd soundtrack. As Alvin wanders, the shopfront window displays and passing traffic bring forth an ever-moving consumerist city centre, one where the individual is lost within its blurred din. Notably, this film – a sex comedy – shares a distinction with *On the Beach* in that they depict characters strolling through the city centre (as Peck and Gardner do along Swanston Street) and living in the moment. This is a rarity within the cinema of Melbourne, where characters move through the city with a purpose; intent on finding a destination.

Director Tony Martin stated that he wanted to make a film set in Melbourne (2003's *Bad Eggs*) that did not feature a single tram. For a city devoid of any cinematically unique landmarks, the tram, as seen in decades of lazy establishing shots on television, assumes the role that the Harbour Bridge or Opera House play in Sydney. In utilizing this iconography, Melbourne thus becomes a city of movement. Never has this been better exemplified than in *Monkey Grip* (Ken Cameron, 1982) in which Nora is often seen on a tram travelling into the city. Street scenes often feature trams in the background and, in one notable moment, as she bicycles through a park near the Exhibition Buildings, one is reflected on a mirrored wall behind her. In a narrative

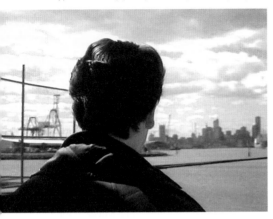

Above © 1992 The Australian Film Commission / Australian Film Finance Corporation (AFFC) / Film Victoria Opposite © 2009 Summit Entertainment

focused on transience and the characters' inability to maintain stability, the tram evokes their constant movement.

Modern Melbourne's mishmash of architectural influences and stylings allows for some imaginative spatial movement of characters within the central business district. In *The Book Of Revelation* (Ana Kokkinos, 2006) Daniel (Tom Long) crosses the Yarra from the smooth contours of the Arts Centre. In an act of geo-spatial bafflement he finds himself the only person in the European-hued Crossley Street and there his nightmare begins. *Angel Baby* (Michael Rymer, 1995) centres on the relationship between a couple suffering mental illness. Their first conversation occurs within the austere confines of the Treasury Buildings complex and their walk (via a jump cut) ends under the brutalist promenade leading into Southbank. In a heartrending film with a cold, bleak aesthetic, the characters haunt the grim metallic bus stops, roadways, and building sites towards the Spencer Street end of the city, an area that has rarely appealed to the camera eye. In contrast is Collins Street, the financial hub of the city and a home to both classical sandstone monuments to the banking sector of the late nineteenth century and the modernist towers of steel and glass that house the money marketeers of today. *Hunting* (Frank Howson, 1991) attempts an erotic descent into a Lynchian abyss once entering the glass and mirrored Collins Street portal.

The notion of Melbourne as a commercial capital is taken to its endgame in the drama *The Bank* (Robert Connolly, 2003) in which unscrupulous financial market manipulation occurs from the highest vantage points of the city. Seldom seen from ground-level in the film, Melbourne is viewed from the sky out of the panoramic windows of gleaming office towers. This is a deregulated Melbourne in which the fortunes of the markets rest on the whim of the Gods residing in the skyscrapers that now compose its skyline. In a montage reminiscent of Godfrey Reggio, the camera prowls these mirrored structures to a score not dissimilar to those of Philip Glass. If the Manichaean melodrama of *The Bank* does see decency eventually prevail, then what of the dehumanized Wenzil (David Field) of *Ghosts... of the Civil Dead* (John Hillcoat, 1988), a brutalized maximum security prisoner released into society, the film's final scene seeing him descending Parliament Station's escalator, his poison ready to spread into the veins of the suburbs?

Melbourne is all things within the centre, but from the outside it haunts those who seldom or never visit it. In *Spotswood* (Mark Joffe, 1992) and *Holidays on the River Yarra* (Leo Berkeley, 1991) the city looms large over the wastelands of the western suburbs. A symbol of escape, it is a place its characters will never reach, yet for the monied denizens of *Irresistible* (Ann Turner, 2006) and *The Bank* it glitters at night, the lights ornamenting the West Gate Bridge, resembling a gleaming piece of jewellery, easily taken – if wanted.

Melbourne is all things to all people and all film-makers. Evolving and adaptable, it is a location that has finally broken free of the *On the Beach* legacy. Yet in 2009 the Nicolas Cage apocalyptic thriller *Knowing* (Alex Proyas) was filmed in Melbourne, featuring scenes on the grounds of the State Library. That Melbourne was now standing in for Boston is a consequence of globalization in international film-making. However, it does show that the spectre of Stanley Kramer has not been completely erased. ✢

**Melbourne is all things to all people and all film-makers. Evolving and adaptable, it is a location that has finally broken free of the *On the Beach* legacy.**

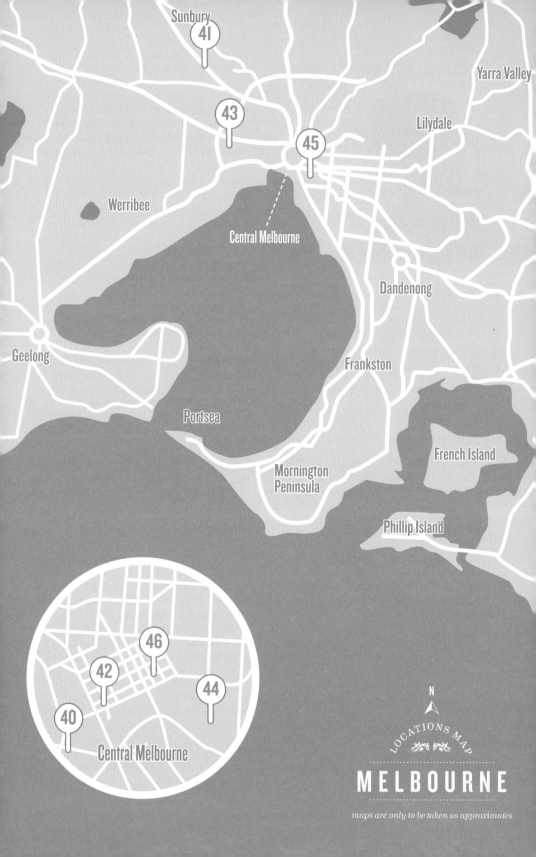

# MELBOURNE LOCATIONS

## SCENES 40-46

# SALAAM NAMASTE (2005)

LOCATION *The Webb Bridge, Docklands, VIC 3008*

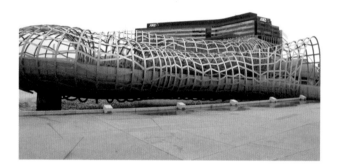

**MELBOURNE WAS IN** the midst of redeveloping its Docklands region of the Yarra River at the beginning of the new millennium. Influenced by the construction of the London Docklands in the 1980s, the Melbourne Docklands project saw the construction of a contemporary new suburb, complete with riverside residential apartments and an entertainment zone of restaurants and stadiums. The pedestrian and cycling Webb Bridge was built in 2003 to span the river and link the city to this new suburb: recycling parts of an old rail bridge into a fluid new shape, it represents a fusion of the historic and the modern. Similarly, Siddharth Anand's Salaam Namaste explores the suture of the new and the old through a love story between two Indian expatriates, Amby (Preity Zinta) and Nick (Saif Ali Khan). As the first Indian film production entirely filmed in Australia, the film explores the new opportunities that are available in the Australian city, which for Amby include radio DJ-ing and the chance to become a surgeon. Singing in her bright surfer clothes and unaccompanied on the bridge, Amby seems the epitome of an independent Indian woman, free in her newly chosen country to pursue a fresh identity, one seemingly without the restrictions of family duty and tradition. Yet the twisting shape of the bridge also serves as a foreshadowing within the structure of the film itself, as in the subsequent scene Amby discovers that she is pregnant and her relationship with Nick takes its own dramatic turn.
➽ *Gemma Blackwood*

(Photo © Steve Davidson)

*Directed by Siddharth Anand*
**Scene description: Amby sings on the Webb Bridge, Docklands**
**Timecode for scene: 1:09:55 – 1:10:34**

# KENNY (2006)

LOCATION *Calder Park Chapel, Calder Park Raceway, Calder Park Freeway, Keilor, VIC 3036*

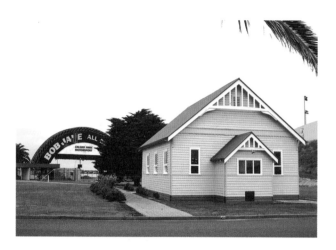

**'IT'S A PRETTY STRANGE PLACE...** to have a church... at a racetrack,' says the eponymous Kenny (Shane Jacobson), whose unenviable job it is to install, maintain and, worst of all, empty portable toilets at many of Melbourne's largest events. The camera shows a small wooden chapel, situated improbably in Melbourne's Calder Park Raceway, home of the legendary 'Thunderdome' auto-racing track. A chequered flag hangs above the altar besides a crucifix apparently made from car parts; a stained glass window shows a contemplative racing driver. 'That's why I choose to come here...' continues Kenny, as the noise of groaning engines and wailing tyres filters in. 'It's a very calming place.' We cut to the cacophony of the drag racing outside. It's a simple joke but a brilliant one, and many must laugh as much at the commitment it took to build the chapel for just one short scene as at the scene itself. But they are wrong to. Like the famous house under the rollercoaster in *Annie Hall* (Woody Allen, 1977), the Calder Park Chapel seems a structure so ludicrous it must have been built for the comedy movie that made it famous – and, again like that house under the rollercoaster, the Calder Park Chapel is real. From 1919 to 1998, it was the Westgarth Baptist Church, but was then given to Calder Park Raceway and moved there, for use by Calder Park's chaplain. As Kenny says, 'They've got it here for the drivers, somewhere... they can say a prayer before... a dangerous race.' ⤞ *Scott Jordan Harris*

(Photo © Amber Moriarty)

Directed by Clayton Jacobson
Scene description: A very calming place
Time code for scene: 0:40:42 – 0:42:15

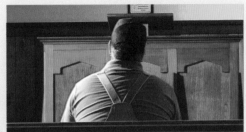

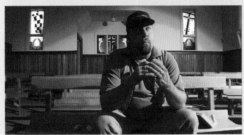

# IRRESISTIBLE (2006)

*Immigration Museum, 400 Flinders Street, VIC 3000*

**ANN TURNER'S URBAN MYSTERY**, *Irresistible*, sees a dangerous romantic triangle of deception play out between Sophie Hartley (Susan Sarandon), her husband Craig Hartley (Sam Neill), and his co-worker Mara (Emily Blunt). Set within the inner-suburbs of Melbourne, the film occasionally ventures directly into the CBD. Sophie, a deeply disturbed and emotionally unravelling woman, succumbs to paranoia and follows the younger Mara through the streets of Melbourne. Outside the National Gallery of Victoria, she notices packs of zombie-like pedestrians gawking at her. A long day at work or do these people know something that Sophie doesn't? The Immigration Museum as a location is a peculiar one. Sitting on the busy Flinders Street, but nestled further down away from the city's main public transport hub of Flinders Street Station, its old architectural exterior is fronted by billowing flags made of bright fabrics in primary colours, and with greenery poking through its cast iron fence. Despite its central location, you would rarely notice heavy traffic going in or out of its large wooden doors on any given day. The Immigration Museum is hardly an ominous building, but Turner's film-making makes it one, as Sophie navigates the staircases and showrooms of the museum with their high ceilings and large pillars. Sophie hurriedly exits once being spotted by Mara, but not before noticing the exhibit on orphaned children of war that will play such an important role in unravelling *Irresistible*'s mysteries. **→Glenn Dunks**

(Photo © Steve Davidson)

*Directed by Ann Turner*

**Scene description:** *Sophie spies on the suspicious Mara*
**Timecode for scene:** *0:45:38 – 0:47:28*

# NOISE (2007)

LOCATION *Bell Street, Sunshine West, VIC 3020*

**AN AUSTRALIAN CRIME DRAMA** with a difference, Matthew Saville's *Noise* sees a young Constable Graham McGahan (Brendan Cowell) diagnosed with tinnitus and put to work in a suburban mobile caravan station on the lookout for witnesses to a brutal murder. Filmed predominantly in the western suburbs of Melbourne, *Noise* strikes great irony out of the fact that its real world setting is the suburb of Sunshine when, really, it looks like a truly dim place to live. With its nondescript streets and local shopping strip of a milk bar and little else being used to great effect, Saville's cop story eschews the traditional high-intensity thrills of the genre and aims for a slower pace that is more in tune with its atmospheric location. Constable McGahan ('Mc as in McDonalds, Gahan as in if you can read it's written right here on my nametag') strikes up a friendship with Dean Strouritis (Luke Elliot), but their first encounter is less than idyllic. Drunk and angry, Dean stumbles past the police caravan before getting into the very sort of violent altercation so often spoken about on the news. But behind those bloodshot eyes Constable McGahan sees the hidden pain that Dean is hiding. Much like Sunshine and its surrounding areas, a violent reputation is likely a mask for something far more troubling. Far removed from the more cosmopolitan world of the city some 11 km away to the east, *Noise*'s dark beating heart is the people whose internal anxieties are expressed in outwardly physical ways. **⊷Glenn Dunks**

(Photos © Amber Moriarty)

*Directed by Matthew Saville*
**Scene description: Constable McGahan has an altercation with a a drunk**
*Timecode for scene: 0:41:22 – 0:44:18*

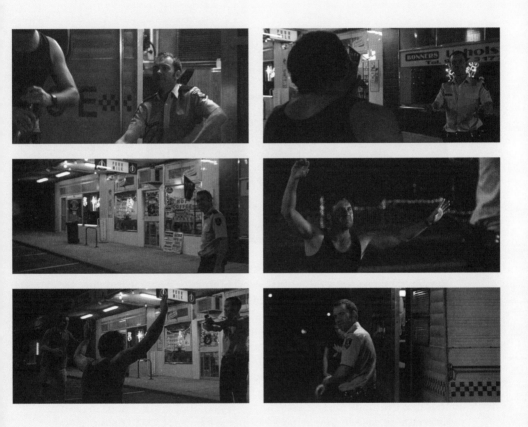

# THE JAMMED (2007)

*Cremorne Take-Away, 20 Cremorne Street, Richmond, VIC 3121*

**WHATEVER THE MENU ON OFFER**, the humble takeaway outlet is a familiar sight in cities all over the world. Their eclectic customer base, drawn from all sections of the populace, mean these nondescript but ubiquitous spaces are fully embedded into the fabric of urban life. Their commonplace nature is used to great effect in Dee Mclachlan's sex trafficking drama *The Jammed*. Loosely based on court transcripts and forced prostitution cases, McLachlan's self-penned exposé of the sleazy underbelly of the city, a micro, location-specific insight into a macro global problem, uses the small Cremorne Take-Away to juxtapose the humdrum with the dramatic during a sequence where an attempt is made to free three trafficking victims from the clutches of one of their captors. After being sucked into a mother's attempts to track down her missing daughter Ruby (Sun Park), Ashley (Veronica Sywak), with the reluctant help of her on-off partner Tom (Todd MacDonald), first trails the car carrying Ruby and her fellow captives and then seizes her opportunity to approach the girls as the driver stops to pick up a takeaway. During the struggle that ensues Ruby and Krystal (Emma Lung) get away but Vanya (Saskia Burmeister) fails to escape the clutches of the henchman. This scene, fraught with tension, potentially life threatening consequences and a bittersweet climax, relies on its everyday shooting location to make a wider point. It may be Melbourne here, but it could be any number of other cities around the world. ➥*Neil Mitchell*

(Photo © Amber Moriarty)

*Directed by Dee McLachlan*
*Scene description: 'We could get a takeaway'*
*Timecode for scene: 0:58:09 – 0:1:01:46*

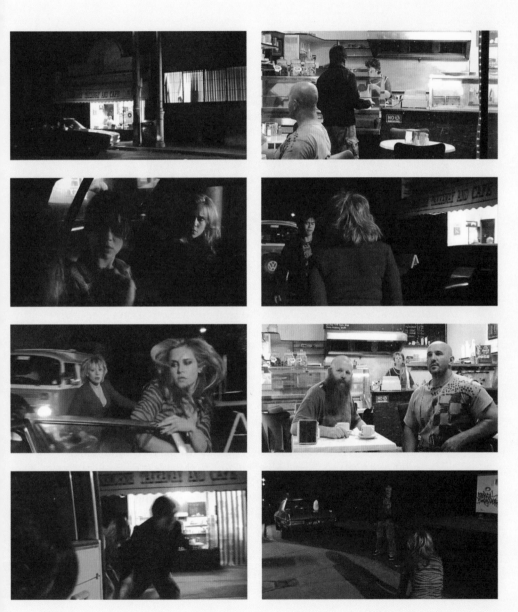

Images © 2007 Film Victoria / Jammed Films / The Picture Tank

# ANIMAL KINGDOM (2010)

LOCATION

*Priceline Pharmacy, 299 Chapel Street, Prahran, VIC 3181*

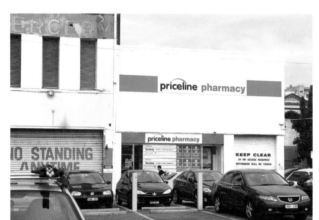

**CONTINUING THE AUSTRALIAN CRIME** cinema trend, *Animal Kingdom* juxtaposes tragedy and comedy in the underbelly of suburban Melbourne. After his mother passes away, 17-year-old Joshua 'J' Cody (James Frecheville) turns to his estranged grandmother for support, unwittingly becoming ensconced in the criminal enterprise of his bank-robbing, drug-dealing uncles in the process. As the police close in on the clan, young J is caught in the middle of his uncle's Machiavellian machinations. Given a stark initiation into the family business, J is faced with reconciling his blood bond and his nagging conscience. Central to the establishment of the criminal dynamic is the relationship between ringleader Pope (Ben Mendelsohn) and his best friend Barry (Joel Edgerton). As their freedom is threatened, the two rendezvous in a local pharmacy, swapping concerns for the present and future. Attempting to mask their difference whilst other shoppers pass by, the men linger in the aisles, departing separately to avoid attention. Outside lays a turn of events that will permanently change their relationship. Priceline in Prahran provides the setting for the pivotal scene, as the epitome of a normal environment. Household products line the shelves, and locals attend to their daily shopping, as their conversation plays out. When the climax comes, the violence and brutality is at stark odds with the safe confines. Accordingly, the exchange illustrates the complex family drama that lays beneath the substantial crime wrapping, with the usual dysfunctions multiplied by the pressure of a life lived outside the law. **••Sarah Ward**

(Photos © Amber Moriarty)

*Directed by David Michod*
**Scene description: Barry and Pope meet at the local pharmacy**
**Timecode for scene: 0:21:01 – 0:23:37**

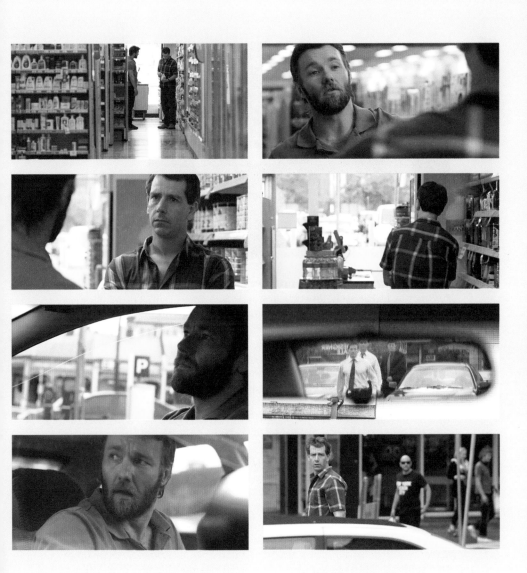

# I LOVE YOU TOO (2010)

*Grand Hyatt, 123 Collins Street, VIC 3000*

**WRITTEN BY MELBOURNE COMEDIAN** Peter Helliar and directed by first-timer Daina Reid, *I Love You Too* centres on a romance stifled by commitment issues. For Jim (Brendan Cowell), saying those three little words proves an insurmountable task, with girlfriend Alice (Yvonne Strahovski) unhappy with the lack of assurance. Despondent, Jim strikes up a friendship with Charlie (Peter Dinklage), overcoming diverse backgrounds to bond over shared problems of the romantic persuasion. Based on Charlie's advice, Jim sets about changing his life, determined to win Alice back by becoming the man he thinks that she wants. Pondering romance in all its guises, *I Love You Too* explores the stages of intimacy that eventuate as affection progresses. From the throes of infatuation to the routine of marriage, the film charts the unravelling of love, with Jim's escapades balanced by the amorous fortunes of his family and friends. Charlie's story represents the realization of fantasy, as he pursues his feelings for a supermodel (Megan Gale) first glimpsed adorning the side of a bus. That their initial meeting takes place in the plush surrounds of the Grand Hyatt Melbourne acts to accentuate the heightened nature of their interaction, augmented further by the comedic yet dismissive exchange with the concierge (Hamish Blake) in the lobby. The oppressively glistening surfaces of the foyer reflect Charlie's romantic aspirations, within an environment so evidently foreign to his character. Accordingly, the setting – and amusing encounter that occurs – exemplifies the intersection of dreams and reality in the search for love. ✦*Sarah Ward*

(Photo © Steve Davidson)

*Directed by Daina Reed*
Scene description: Charlie meets up with Francesca at a hotel bar
Timecode for scene: 1:24:33 – 1:25:25

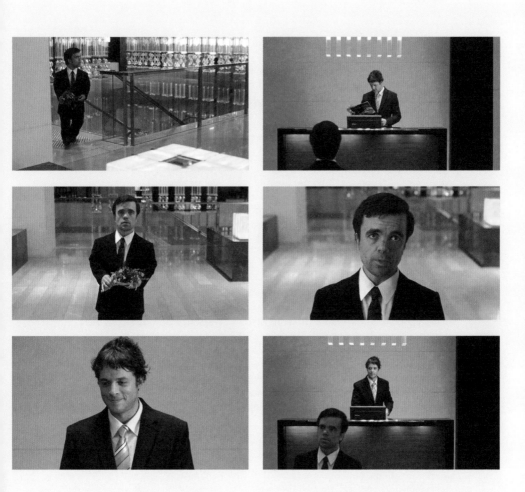

# THE WORLD SEEMS DIFFICULT

Text by
GEM
BLACKWOOD

*Youth, Melbourne, Cinema*

**A MAJOR INFLUX** of immigrants at the end of World War II transformed Melbourne into a major Australian metropolis, a complex multicultural hub with newly attendant problems ranging from traffic congestion to drug usage and ethnic violence. In the 1960s, an ambitious programme saw the replacement of nineteenth century 'slum' zones with ultra-modern high rise housing projects throughout the inner urban suburbs, imparting the city with a brutal new form of architecture which would have appeared almost 'international' to those who played in the buildings' shadows. Then, the city's push outwards into suburban sprawl was coupled with the rise of a newly empowered youth culture. The regular appearance of youngsters in the media first manifested in local pop music and on television in the 1960s. A number of young Melbourne music artists and groups – Johnny Farnham, The Seekers, Normie Rowe, etc. – rose to stardom and success. By the 1970s, the city's population had increased to over two million, and a new post-war generation were coming of age, both on the streets and on screen.

Unsurprisingly then, many films set in Melbourne have focused on young people and urban subcultures: after all, it is the youth who are the ultimate inheritors of this developing city and perhaps best posited to understand and navigate their way through its multiple facades and its hidden, seedy levels. Against the natural realism of Australian films set in rural areas, movies set in Melbourne were largely freed from having to conform to nationalistic clichés of place – they could be insular, idiosyncratic, funny or dark. Tim Burstall memorably documented the plight of young men in the city through a series of light-hearted and risqué 'ocker' comedies. *Stork* (1971) outlined the cartoon-like exploits of a sociopathic young man (played by Bruce Spence) at odds with the mores of society and class. Then, the immensely successful sex farce *Alvin Purple* (1973) – followed by *Alvin Purple Rides Again* (1974) and a television series in 1976 – pitted Graeme Blundell's gormless Casanova against Melbourne women and society at large (so to speak). The obvious chauvinism of these films obscures their genuine social critique – in each film one can detect a challenge to traditional gender roles, which is coincident with the rise of second wave feminism in Melbourne.

The city's ongoing love affair with rock 'n' roll is reflected on film across the decades. The rock documentary *Sunbury* (Ray Wagstaff and John Dixon, 1972), focused on the eponymous music festival which has become now legendary in the history of the Melbourne music scene, whilst Chris Löfvén's *Oz: A Rock 'n' Roll Road Movie* (1976) likened the city to a glam-rock Oz (from *The Wizard of Oz*), a dangerous and decadent town filled with seductions. The city was equally dangerous for the young protagonists of *Dogs in Space* (Richard Lowenstein, 1986), a romanticized remembrance of the city's punk history. The late INXS frontman Michael Hutchence starred in this coming-of-age story set in the impoverished world of inner-city share-housing. This is a period of Melbourne history undergoing a revival of interest in recent years with the release of two of Lowenstein's music documentaries *We're Livin' on Dog Food* (2009) and *Autoluminescent: Rowland S. Howard*, (co-directed with Lynn-Maree Milburn in 2011).

Drug addiction, experimentation, and hedonism are constantly revisited

Above © 1992 The Australian Film Commission / Film Victoria

subjects in youth oriented Melbourne-based films, starting with the controversial underground film *Pure S* (Bert Deling, 1975) that was shot chaotically across the streets of Carlton. *Monkey Grip* (Ken Cameron, 1983) was a more sobering examination of substance abuse, portraying a young mother negotiating a difficult relationship with a heroin-addicted boyfriend. Equally self-destructive in their own right, the anarchic young villains of *Mad Max* (George Miller, 1979) used customized automotives to wreak havoc in the city's outer districts. Then, in another look at gang violence, the neo-Nazi thugs in *Romper Stomper* (Geoffrey Wright, 1992) menaced the working class and multi-ethnic suburb of Footscray with racist belligerence. In *Head On* (Ana Kokkinos, 1998) the underlying aim is for the pursuit of pleasure rather than of injury: for a young Greek gay man Ari (Alex Dimitriades) to source sex and drugs in the alleys and bars of Brunswick as a necessary escape from the problems of regular life.

**...many films set in Melbourne have focused on young people and urban subcultures: after all, it is the youth who are the ultimate inheritors of this developing city and perhaps best posited to understand and navigate their way through its multiple facades and its hidden, seedy levels.**

Other films take on a more comic tone, representing young people as innocent victims of a mean-minded broader community. Set in the self-absorbed sphere of the university, *Love and Other Catastrophes* (Emma-Kate Croghan, 1996) pits students against lecturers; the little-seen *Strange Fits of Passion* (Elise McCredie, 1999) depicts a young Carlton woman on an endless quest to lose her virginity to an eligible candidate. In *The Castle* (Rob Sitch, 1997), the guileless and endearing young man Dale Kerrigan (Steve Curry) narrates his blue collar family's David and Goliath battle to save their condemned home from industrial development.

While the long-running TV soap *Neighbours* (Reg Watson, 1985– ) has largely concentrated on the adolescent trials of middle-class teenagers from Melbourne's affluent eastern suburbs, films on the city's teenagers have been more wide-ranging in thematic scope. In the early 1980s, two films directed by Michael Pattinson and starring Vince Colosimo, *Moving Out* (1983) and *Street Hero* (1984) both offered naturalistic commentaries on the inter-cultural difficulties on a young son of Italian immigrants. In *The Big Steal* (Nadia Tass, 1990), 18-year-old Danny Clark (Ben Mendelsohn) is duped buying a Jaguar from a used car salesman, and needs to find his own justice as well as win the affection of Joanna (Claudia Karvan). Equally light-hearted, the teen film *Hating Alison Ashley* (Geoff Bennett, 2005) is a suburban moral fable on the curbing of adolescent envy. Then, there are darker narratives, often set in poor or working-class suburbs, showing systemic problems in the city's formation. *Mallboy* (Vincent Giarrusso, 2001) illustrates the alienation of teenage life in the suburbs, where the local shopping centre becomes a vital social venue when home life is endangered. A modern 'Melbourne ganglands' version of *Macbeth* (Geoffrey Wright, 2006) likens a group of private school girls to the renowned prescient witches of Shakespeare's play. More recently, *Animal Kingdom* (David Michôd, 2010) delineates a young man (James Frecheville) pushed to an ethical limit: here is a 'coming of age' film with tragic consequences. ✦

# GO FURTHER

*Recommended reading, useful websites and further viewing*

## BOOKS

**Australian Cinema 1970–1985**
By Brian McFarlane
(Secker & Warburg, 1987)

**Australian Cinema After Mabo**
By Felicity Collins and Therese Davis
(Cambridge University Press, 2004)

**Australian Cinema: The First 80 Years**
By Brian Adams and Graham Shirley
(Currency Press, 1983)

**Australian National Cinema**
By Tom O'Regan
(Routledge, 1996)

**Design City Melbourne**
Leon Van Schaik
(John Wiley & Sons, 2007)

**Diasporas of Australian Cinema**
Edited by Catherine Simpson, Renata
Murawska and Anthony Lambert
(Intellect Books, 2009)

**Directory of World Cinema:
Australia & New Zealand**
Edited by Ben Goldsmith and Geoff Lealand
(Intellect Books, 2010)

**Film and Travel, Asia, Oceania, Africa:
Traveling the World Through Your Favorite
Movies**
Edited by Anne Ishii
(Museyon Guides, 2009)

**Melbourne Architecture**
By Philip Goad
(Watermark Press, 1999)

**Melbourne Then and Now**
By Heather Chapman and Judith Stillman
(Cameron House, 2007)

## WEBLINKS

*www.infilm.com.au/*
resource devoted to Australian cinema.

*aso.gov.au/* (Australian Screen Online)
Australia's audiovisual heritage website.

*www.innersense.com.au/mif/index.html*
devoted to indie film-makers in Melbourne.

*www.madmaxmovies.com*
a comprehensive website focusing on *Mad Max*.

*www.marvellousmelbourne.org/drupal/*
Website focusing on 'protecting city, country and coast'.

*www.nfsa.gov.au/*
(National Film & Sound Archive)
Australia's national audiovisual archive.

*www.onlymelbourne.com.au/*
online guide to what's on in Melbourne.

*technicolouryawn.com/*
Melbourne movie-going during the R rated years:
1970–84.

*www.sensesofcinema.com/*
Melbourne based online film journal.

*miff.com.au/*
official website for the 'Melbourne International
Film Festival'.

## FILMS

**Jazz Scrapbook: Melbourne 1935–1955**
Nigel Buesst, dir. (1982)
Documentary on Melbourne's jazz scene.

**Marvellous Melbourne:
Queen City of the South**
Charles Cozen Spencer, dir. (1910)
Early documentary on the city.

**Melbourne Shuffler**
Stephen Coles, David Knispel and Michael
Knispel, dirs. (2005)
Film about the 'Melbourne Shuffle' dance style.

**Rash**
Nicholas Hansen, dir. (2005)
Documentary about illegal street art in Melbourne.

# CONTRIBUTORS

*Editor and contributing writer biographies*

**NEIL MITCHELL** is a writer and editor based in Brighton, UK. He edited the London edition of the *World Film Locations* series and co-edited Intellect Books' *Directory of World Cinema: Britain* volume. He writes for *The Big Picture, Electric Sheep* and *Eye For Film*. He is currently working on a monograph on Brian De Palma's *Carrie* (1976) for Auteur Publishing.

## CONTRIBUTORS

**MYKE BARTLETT** is a freelance journalist, emerging novelist and veteran podcaster. His work has appeared in publications such as *Metro, Dumbo Feather* and *The Age* newspaper. Currently, he earns a crust reviewing cultural things for Melbourne glossy *The Weekly Review*. Over the last few years his podcasted fiction has been downloaded more than half a million times. In 2011, he won the Text Prize for his young adult novel *Fire in the Sea*, which will be published by Text Publishing in August 2012.

**GEM BLACKWOOD** is a freelance film writer and long-term movie lover based in Melbourne, Australia. She recently completed a research Ph.D. exploring the phenomenon of contemporary film tourism at the University of Melbourne, which took her on a journey to film hot-spots from Canberra to California. She contributes both to academic journals and mainstream cinema publications, and recently wrote the Australian section for the guidebook *Film and Travel, Asia, Oceania, Africa: Traveling the World Through Your Favorite Movies* (Museyon Guides, 2009)

**DEAN BRANDUM** is a Ph.D. candidate at Deakin University in Melbourne, whose thesis will explore notions of the box office viability of British films in the United States between 1963–72. A born and bred Melburnian, he has taught at RMIT, Swinburne and Latrobe Universities, and runs the website *technicolouryawn.com*. He also thinks the coffee in Degraves Street is overrated.

**JULIAN BUCKERIDGE** is the editor of *AtTheCinema*, an online publication that covers daily news and reviews, as well as feature and theoretical articles on all things film. He founded the *AtTheCinema* website in 2010, and is a contributor to many magazines, websites and journals. Julian is studying Film at Monash University and has hosted Q&As and participated in discussion panels. Particular areas of interest include performance, screenwriting, Asian cinema and urban representation. He can be found most days tweeting about film and other cultural and social matters on *@perspicuousness*.

**JEZ CONOLLY** holds an MA in Film Studies and European Cinema from the University of the West of England, is a regular contributor to *The Big Picture* magazine and website, and is co-editor of the Dublin, Reykjavik and Liverpool volumes in the *World Film Locations* series. His book *Beached Margin: The role and representation of the seaside resort in British films* was published by Lulu in 2008 and he is currently working on a monograph about John Carpenter's *The Thing*. In his spare time he is the Arts and Social Sciences & Law Faculty Librarian at the University of Bristol.

**ADRIAN DANKS** is Senior Lecturer and Director of Contextual Studies (including Cinema Studies) in the School of Media and Communication, Royal Melbourne Institute of Technology (University). He is co-curator of the Melbourne Cinémathèque and co-editor of *Senses of Cinema*. He has published widely in a range of books and journals and is currently writing ➜

several books including a monograph devoted to the history and practice of home movie-making in Australia and an edited collection devoted to Robert Altman (Wiley-Blackwell).

**GLENN DUNKS** is a Melbourne-based writer, having grown up in Geelong some 75 km southwest of Melbourne. He has loved movies for as long as he can remember, but the first Australian films he actively obsessed over was the one-two punch of *Muriel's Wedding* (P. J. Hogan) and *The Adventures of Priscilla, Queen of the Desert* (Stephan Elliot) from 1994. He has since become an active member of the local film community, regularly writing about the subject for various publications. He cites Phillip Noyce's *Newsfront* (1978), Peter Weir's *Picnic at Hanging Rock* (1975), and Ray Lawrence's *Lantana* (2001) as the greatest Australian films ever made.

**LISA FRENCH** is Associate Professor in Cinema Studies, Media and Communication at RMIT University. She is the co-author of the books *Shining a Light: 50 Years of the Australian Film Institute* (ATOM, 2009) and *Womenvision: Women and the Moving Image in Australia* (Damned Publishing, 2003). Her film projects include producing the film *Birth of a Film Festival* (Mark Poole, 2003), a film about the first 'Melbourne International Film Festival'. Her professional history includes screen culture posts, including three years as the director of the 'St Kilda Film Festival', and nine years on the board of the Australian Film Institute.

**DR KRISTINA GOTTSCHALL** is a film scholar and early-career academic situated at the leafy campus of Charles Sturt University at Bathurst in New South Wales. Her doctoral work focused on youth-hood in popular Australian film post-1980 from post-structural, pedagogical, feminist and cultural studies'

perspectives. When she first started her Ph.D. she hated Aussie films, but learned to see them through a new lens and now is a bit of a mad devotee. Kristina sees her work crossing the domains of education, cultural studies, film studies, cultural history and social semiotics. She currently lectures in the area of the cultural politics of education.

**SCOTT JORDAN HARRIS** writes for *The Spectator* and edits its arts blog. He is also editor of several World Film Locations books and was editor of *The Big Picture* magazine from 2009–11, before being promoted to Senior Editor. His work has been published in several books and by, among others, the *BBC*, *The Guardian*, *Fangoria*, *Rugby World*, *Film4* and *The Huffington Post*. Roger Ebert lists @ScottFilmCritic as one of the top 50 'movie people' to follow on Twitter and, in 2010, *Running in Heels* named Scott's blog, *A Petrified Fountain* (http:// apetrifiedfountain.blogspot.com), as one of the world's twelve 'best movie blogs'.

**ALEXANDRA HELLER-NICHOLAS** is a visiting fellow at the Institute of Social Research at Swinburne University, and the author of *Rape-Revenge Films: A Critical Study* (McFarland, 2011) . She has published in both academic and non-academic publications on body genres, and is a regular contributor to *Metro* Magazine on Australian horror film. She has spoken regularly on horror at the Australian Centre for the Moving Image, and has been interviewed on horror and trash film culture in media outlets including *JJJ*, *ABC Radio National*, *RRR*, *The Daily Telegraph* (Sydney), *MX* (Sydney and Melbourne) and *The Big Issue*. She runs the *Filmbunnies* blog with Melbourne cinema history expert, Dean Brandum.

**EMMA JANE MCNICOL** is a film lover and writer born in Melbourne. In 2010 Emma

completed her Honours thesis in combined Cinema and Literature at Monash University, and studied Film at the Frei Universitaet Berlin in 2007/2008. She is currently working towards a Law Degree, teaching visual arts at a high school and contributing to film journals and online newspapers when she can. Emma looks forward to starting her Doctoral Thesis in cinema in 2013/2014.

**WHITNEY MONAGHAN** is a Ph.D. candidate at Monash University in Melbourne where she researches queer girls in film, television and digital video. Her work has appeared in the journals *Jump Cut* and *Colloquy* as well as online film magazine, *Screen Machine*. She attempts to maintain a regular web presence at *www.cinethoughts.tumblr.com* and can be found tweeting most days about film, television, Batman and breakfast cereals *@jatneywhitmo*.

**JACK SARGEANT** has programmed movies at festivals and specialist cinemas internationally as well as being the Program Director for the 'Revelation Perth International Film Festival'. He is the author of a number of books on underground and cult cinema including *Naked Lens: Beat Cinema* (Soft Skull Press, 2009), *Deathtripping: The Extreme Underground* (Soft Skull Press, 2007) and *Cinema Contra Cinema* (Fringecore, 1999), and he has co-edited various books on cinema including *Lost Highways: An Illustrated History of the Road Movie* (Creation Books, 2000) and *No Focus: Punk On Film* (Headpress, 2006). In addition he has contributed to numerous collections on topics ranging from Andy Warhol to The Human Centipede, from sex films to the work of William Burroughs. His writings frequently appear in magazines and journals and his cover notes have graced numerous DVDs. Jack regularly appears in documentaries discussing topics including

film, sexuality and subcultures. In his spare time he likes to drink coffee, unless it's late when he prefers a glass of fine wine.

**FIONA TRIGG** is an assistant curator at the Australian Centre for the Moving Image, where she has curated the exhibitions *Mary and Max: the Exhibition* (2010) and *Light Years: Arthur and Corinne Cantrill* (2011).

**DEB VERHOEVEN** is Professor and Chair of Media and Communication at Deakin University. She is President of the Melbourne-based online film journal Senses of Cinema and until recently served as Deputy Chair of the National Film and Sound Archive of Australia (2008–11).

**YASMIN VOUGHT** is a Sydney-based freelance journalist who writes about film, television, sociology and cultural studies. She graduated with a Bachelor's degree in Social Science, but her passion for film and media has greatly influenced her career move towards the field of film journalism. Yasmin has contributed to *Rotten Tomatoes*, *IGN*, *Carnival Askew*, *Machete Girl*, the *Sydney Underground Film Festival* blog, and various other web and print based publications. Yasmin can be found on Twitter posting about film festivals, video games, television, and the absurdity of everyday life at *@yazberries* or her blog at *www.themisenscenester.blogspot.com*.

**SARAH WARD** is a freelance film critic, writer and festival devotee. Her written contributions can be found across a range of cinema, culture, and festival websites including *Arts Hub*, *Trespass Magazine*, *At The Cinema*, *KOFFIA*, the 'Spanish Film Festival' and *SBS Film*'s 'Social Review'. In addition, she has worked for a number of entertainment and arts organizations, including her current role at the 'Brisbane International Film Festival'.

# FILMOGRAPHY

*All films mentioned or featured in this book*